SINGLE EXPOSURES

*Random Observations
on Photography, Art & Creativity*

Photography & the Creative Process
A Series by LensWork Publishing

On Being a Photographer

David Hurn/Magnum
and Bill Jay

*Third Edition, Fourth Printing
Nov 2004*

Letting Go of the Camera

Brooks Jensen

First Edition 2004

Single Exposures

Brooks Jensen

First Edition 2005

Finding an Audience for Your Work

Brooks Jensen

To be released in 2005

SINGLE EXPOSURES

Random Observations on
Photography, Art & Creativity

Brooks Jensen
Editor of *LensWork*

LensWork Publishing
2005

Thanks David,

who has listened to me for so many years,
offered so many corrections to my errors,
and patiently waded through my flawed logic
only to find so many of his brilliant ideas in this book,
uncredited to him as they ought to have been,
herein fully indistinguishable from ideas
I am sure he would just as soon not have
his name attached to.

First Edition, First Printing July 2005

ISBN #1-888803-28-2

Published by:
LensWork Publishing, 909 Third Street, Anacortes, WA, 98221-1502 USA

www.lenswork.com

To order quantities at discount pricing, please call 1-800-659-2130

Printed in Canada

Table of Contents

INTRODUCTION

This book is the result having clearly set out *not* to write a book. Oh, well.

As the editor of *LensWork*, I'm afforded the opportunity every 60 days to write an *Editor's Comment* in which I can express my ideas, voice my frustrations, offer my counsel, preach from my soapbox, and, if I'm lucky, contribute something of value to the century-old discussions of photography and its role in the life of the creative artist. If I'm really lucky, my readers will find what I've had to say both useful and of interest enough to keep them reading. I've always tried to keep in focus the privilege and responsibility those pages grant me.

There are, however, a bushel-full of other observations that never make it into the pages of *LensWork*. These are often snippets of conversations I have with photographers and readers, quick observations of things that cross my desk, fleeting thoughts that ping my brain at the most unusual moments but somehow contribute to my understanding of photography and the creative life.

For 10 years, such observations accumulated as little scraps of paper and notes gathered in odd places around my office. I never quite knew what to do with these ideas until the Internet provided the perfect opportunity. I learned about *blogging*. Blogging is a concatenated word short for *web log* and in most cases takes the form of personal diary or, more recently, a running commentary on politics or the news of the day. It was natural for me to realize this was the perfect vehicle to offer my short comments on photography, art, and creativity. The problem, however, lies in my stubby little fingers—all 10 of which would like to be skilled typists, but only eight of them actually *are* typists, and extraordinarily bad ones at

that. For the items I contribute to *LensWork*, my "writing" should more accurately be known as "dictating, transcribing, and editing." Whereas most blogs are written (by skilled typists) for reading on the Web, it is much more natural for me to create audio recordings. Hence the birth of the *LensWork* "audio blog"—an almost daily addition to our website consisting of random observations, offered in the spirit of "thought for the day." On February 26, 2004—the day of my 50th birthday—I recorded my first audio blog and posted it at www.lenswork.com. I had no reason to type them, no intention of transcribing them, and certainly no idea of assembling them into a book. I've been surprised, overwhelmed, and little shocked that so many people have asked me and encouraged me to do so.

Single Exposures is the result. I've now recorded and posted over 200 audio comments on the Web; this book is a lightly edited transcription of the best of those. We have purposely kept editing to a minimum so that each comment more closely follows the original audio recording. As such, like all such transcriptions where the spoken word is converted for reading, there is a casualness in the text that is purposeful and even conversational. The commentaries here are presented in the same order in which they appeared on the web between February 2004 and July 2005.

Our premise at *LensWork* has always been that photography is, or can be, a way of life; that creativity is more important than technology; that photography is a verb; that images have power and magic to them and deserve more attention than they are generally given. These same themes resonate through the commentaries in this book—which I hope is motivating, inspiring, challenging, thought-provoking, stimulating, and even a bit controversial. These pages definitely contain more questions than answers—a trait consistent with the mind of exploration and creativity that is the most important tool in the life of an artist.

So here you go—truly *random* observations on photography, art, and creativity …

Ages of the Photographers

Well, today is my birthday. And worse than that, it's my 50th birthday! Although I'm feeling quite old today, I have exactly what I need to overcome whatever feelings of age depression I might be having. Years ago, I put together a list of photographers and their most well-known prints, and how old they were when they photographed them—for moments just like today. So, just for a quick review, here are a few ages of photographers when they made their great images:

Alfred Stieglitz, for example, did his great *Equivalents* series when he was 65, and the *Poplars at Lake George* when he was 68. Ansel Adams: *El Capitan* was photographed when he was 50; *Horizontal Aspens* in Northern New Mexico when he was 56; *Portfolios #3 to #7* were all done between the ages of 58 and 74—so, I don't feel so bad there. Brett Weston did *Holland Canal* when he was 61 and *Mendenhall Glacier* when he was 62. Hmm, that makes me feel a lot better.

Edward Weston did *Dunes Oceano in the Light Tones* in 1936 when he was 50; *Surf at Orec* when he was 51; *Zabriskie Point Death Valley*—wow, that's a great image, love that one—when he was 52; *The Wrecked Car on Crescent Beach* when he was 53; *The Rubber Dummies at the Metro Goldwyn Mayer Lot* when he was 53. He didn't publish *California and the West*—that great seminal book—until he was 54.

Joseph Sudek did his pictures of the bread and egg when he was 55. Minor White did *Song Without Words* when he was 52; *Bullet Holes Capital Reef* when he was 53; *Eel Creek, Oregon* when he was 58. Paul Caponigro published *The Wise Silence* when he was 51; *Megaliths* when he was 54; *Seasons* when he was 56. Paul Strand published *The Mexican Portfolio* when he was 50, and didn't even begin *Time in New England* until he was 55. He published *Un Paese* at 65 and *Tir a'Mhurain* at age 72! How about Wright Morris? He

published *God's Country and My People* when he was 58. Wynn Bullock did *Sea Palms* when he was 66; *Navigation Without Numbers* when he was 55; *Erosion* when he was 54.

Gosh, I feel so much better!

You Can't Please All the People

Listening to this ongoing debate about the Mel Gibson film *The Passion of The Christ* reminds me a little bit of going to my first-ever workshop and having my work critiqued. The short story you know—you just can't please all of the people all of the time—even if you please some people exceedingly well some of the time.

I learned this with the first round of critiques that I went to. I showed the same body of work to three different workshop instructors. The first workshop instructor absolutely tore it apart, said it was horrible work and that I ought to start over from scratch. He found nothing redeeming about the work whatsoever. I was devastated. So I went into the next critique, and the next instructor looked at the same body of work and said, "You know, this is really nice work. This shows not only good potential, but some of these are really great. I'd hang them on my wall right now; I think they are that good. So keep up the work, because it's really terrific." And I went out of that critique obviously beaming. Then I went to the third critique and the guy said, "Well, some of these are pretty good, some of them are really pretty bad—so consistency is a struggle. But if you can learn to look at your work more objectively and to separate the good stuff from the bad stuff" and etc. The ones that the third instructor really liked were the ones the second instructor didn't like, and vice versa.

I learned very quickly that in some regards the opinions of others tell us more about *them* than they really tell us about the work.

This doesn't mean that you should stop trying to look at your work critically and learn to be a good editor. But at least for me, what I learned is you can't please all of the people all of the time—and watching this debate over Mel Gibson's new film has just reinforced that lesson. Whenever you create something, whenever as an artist you actually put something out there into the world for people to look at, you're going to please some people, you're going to have a few people who don't like it, you may even have some people who become your enemies—and that is the nature of creation. There is always a critic, and there is always a fan.

The Market as a Source of Financing

Here's an odd comment about this Mel Gibson movie: Everybody's talking about how much the movie cost—about $30 million bucks directly out of Mel Gibson's pocket—and in the first weekend, according to the reports that I'm reading off the Internet, it grossed $117 million. So here's my observation: Do you think Mel Gibson is going to have to worry about the next movie he wants to generate, and the $30 million that it might cost? Or will he pretty much be able to do whatever he wants, to make whatever movie he wants to create, whatever artwork he wants, because he can now afford it … because what he did was so successful?

It dawns on me that as photographers there is a lesson to learn here—that a lot of times we complain about how expensive camera equipment is, how expensive film and paper is—and it is expensive, if you're not selling anything, if you're not marketing anything, if you've priced your work so high that no one buys it. But as soon as you have a revenue stream, that is to say as soon as you *engage the market*, and recognize that the market is the solution for being able to afford your next project, then suddenly there's an importance to

doing something with the work that you have now so that you can open the door to do the work that you want to do down the road. Today's commercial success fuels tomorrow's creative ideas and creative projects. We can't ignore the power of the market to influence and affect our creativity in ways that open doors and make things possible. This may sound naïve, but it occurs to me that if you want to be able to afford all of the equipment that you dream of, all the paper and chemistry that you dream of, all the travel you dream of, then one thing that could be important to do is to engage the market by selling what you have now—making it affordable and generating the cash so that future projects aren't inhibited by budgetary constraints.

Just my thoughts about Mel Gibson's movie.

How Protozoans Led Me to Ansel Adams

When I was a young boy, one of my great passions in life was protozoology. I used to spend hours and hours sitting in front of the microscope, fascinated by this world of creatures that would live and die and have their little dramas in a *scale* and in a *place* that was beyond our imagination. When I got into high school, I was so fascinated with protozoans that I decided to engage a science project to try to photograph them. I discovered fairly quickly that photography was a difficult thing and I needed a certain amount of skill that I didn't have. So I signed up for a photography class.

In that photography class I was given an assignment to do a book report, and I could choose from three photographers to do my assignment on. The three photographers I had to choose from were Ansel Adams, Edward Weston, and Wynn Bullock. Needless to say—as evidenced by the fact that here I am 33 years later as the editor of *LensWork* and doing a blog on photography—that my

interest in protozoology was quickly supplanted by my fascination with artwork. And there are a couple of interesting elements of this story I thought I'd share with you.

First, I've often wondered what would have happened if I had instead been given the assignment to review work by, say, Nan Goldin. I can guarantee you I would have had absolutely no interest in photography whatsoever, because her photographs don't interest me. I'm not interested in that entire aspect of photography. So learning something about the history of photography and finding somebody who spoke to me aesthetically was a very important part of my discovering this passion in my life.

Second, what would have happened if the technology of making photographs through the microscope had been incredibly easy? What if, for example, exposure wasn't a guess, film developing wasn't difficult, cameras weren't complicated? What if I didn't have any technological challenges? I may never have signed up for a photography class, which means I may never have discovered how interesting photography is. So for all you teachers, parents and mentors out there, it's not a bad thing to make it a little difficult, to insist that your students learn something about history, and to pass on what may develop into a great passion in their life.

The Motivation of a Deadline

Last night—that is to say, Sunday night at about midnight—we wrapped-up the production of *LensWork #52* and uploaded it via the Internet to the printer. I worked about 21 hours this weekend between Saturday and Sunday. I don't say this to ask for sympathy; I don't say this because I feel somehow pressed upon; but rather I mention it because it occurs to me *what a powerful motivation a*

deadline is. We had to have the files in to the printer Sunday because the issue is going to press this week.

I don't know why I don't use this technique more with my own artwork. The most productive I've ever been in my life in terms of getting prints done has been either when I had a deadline for an exhibition or when I was going to attend a workshop. I bet if you think about this, you're probably like me. You've gotten more prints done, more matting, finishing, printing, etc. done, completed—every little "i" dotted and "t" crossed—when you had a firm, inflexible deadline. And why not employ that on a regular basis?

I've often thought that if I were really smart I'd have a deadline about once a quarter for a major project, and maybe more frequently for smaller projects, and maybe once a year for a really serious big-time project.

Deadlines … yeah, what a great idea. But for now I think I'll take the rest of the day off!

Book Remainders

Yesterday, when I was up in Canada doing the press check for *LensWork #52,* we had a little extra time so we popped over to the *Chapters* bookstore in the shopping mall. *Chapters* in Canada is kind of the functional equivalent of *Borders* or *Barnes & Noble* here in the States. They also have a large section of remaindered books—books that the publishers have discontinued. And there on the shelf for $9.95 was a photography book that I had received as a sample from the publisher to review not six months ago—and it was a $65.00 retail book. There it was in *Chapters* as a remaindered book for under $10—*Canadian.* Every time I see a situation like this, I can't help but wonder who's funding all these books and who's losing all this money on these books that don't sell?

For the last 40 or 50 years, books have been the primary way that we have publicized ourselves in photography and seen new photographs. Books have been way more important than galleries, exhibitions, and museums. Books have been the medium of photography. But the financial dynamics of the book business are so bad, so many people are losing so much money now, that something has got to change. This can't go on. The book business is just miserable! To sell a book to *Barnes & Noble* or to *Borders* you have to sell them at 60% off retail—that's what they pay for it! How does a book publisher make any money? How can you afford to publish books? This entire paradigm of distribution is an incredibly expensive and inefficient way to get photography out. Something's got to change.

I love books, I think they're great, but they are a terrible financial risk and a terrible financial loss every time a book gets published and doesn't sell. About one out of ten do well according to the statistics in the publishing world. That's a tough way to make a living, and I really feel sorry for these people that are publishing these books and then losing their shirts!

The Medium is Only the Medium

I love electronic gadgets, and one of mine broke this morning. I have this little CD player that will play CDs that I record on my computer, and it will also play MP3 and WMA files. It's a great little thing called a Rio Volt. It broke this morning and it's virtually irreparable, so I threw it in the garbage can. My immediate reaction was to go out and buy another one. I've got a lot of music on CDs that are compacted MP3 files and WMA files so I can have hours of music on a CD. But I also have something called a Creative Nomad. This is a little portable device that has a 20 GB

hard drive in it—and on this thing I can put literally hundreds of hours of music. So I don't need the CDs. And then Sony has a new thing called a 1GB Hi-MD (high quality mini disc). Boy, you could put a lot of music on that. And I got to thinking, how many different media do I need? I don't need all of these things; maybe what I ought to do is consolidate. Makes sense. Because the message is not in the medium, the message is in the message—to take issue with Marshall McLuhan—and I really don't care about what the medium is—what I care about is the content.

And that leads me to photography.

Whether it's on the Web; whether it's in a book; whether it's on the wall; whether it's in a poster; whether it's in ever-so-many different kinds of presentation—why did so many of us for so many years spend all that energy focused on the finely crafted silver print? As though somehow the medium itself had some magic? Other than the fact that it was fun—and we enjoyed the darkroom, and there were a lot of challenges and it was stimulating—but, in terms of the photographic message or the photographic content ... hmmm.

If I don't care what the medium is when I listen to music, why would I care what the medium is when I look at photography? That's a hard question for me because I'm a photographer and not a musician. But maybe it's worth asking *because* I'm a photographer and not a musician.

The Primary Medium of Photography

I caused a little mini-furor the other day when I said that books are the primary medium of photography, and that gallery and museum exhibitions hardly count. And I just want to clarify that a little bit because it's a rather radical thought.

There's no question that the original medium of photography is

the fine art print. Well, with the exception of the case of slides or digital photography—but I digress. The *primary* medium of photography is different than the *original* medium of photography. By that I mean the primary way that you and I probably know photographs is from books. I can bring forth in my mind's eye ever-so-many photographs that have been influential and important to me in my life, and as artwork both as a photographer and as a human being I really appreciate, but I've never seen the originals. I've only seen them in book reproductions.

So I might say the primary medium of music is the CD, but the original music is the concert. But more of us know music from CDs than we know from concerts. That's what I'm trying to get at here. But I suppose I should also say Web sites and magazines and other forms of reproductions (posters and whatnot)—anything that takes the photograph and puts it outside the limitations of a gallery or museum exhibition. The primary limitation of gallery and museum exhibitions is that they are limited in both time in geography—two serious limitations that books and other printed media don't have.

That's why books, I think, are the primary medium for photography.

Old Negatives

For 30 years now I've dutifully organized and cataloged every negative I've ever made, even the bad ones. And I've got them all in Light Impressions boxes and I can put my hands on them in an instant because my indexing is so good. But why? I have no interest in going back and printing negatives that are 30 years old, but for some reason I've operated now for 30 years under the assumption

that at some point in time I would go back and visit those old images and make great artwork from those old negatives.

But now that I'm here, 30 years after I started doing that, I can honestly say that most of those images—as a matter of fact, virtually all of those images—hold very little interest for me now. I'm interested in what I'm doing today.

So, why have I kept them all this time? I suspect it's one of the great photographic myths: the idea that because we've encapsulated the artwork in the negative that at some point down the road we can liberate it in a printing session and make great artwork from it. The reality is that the artwork is never in the negative; *the artwork is in the artist.*

And now that I'm 30 years older than when I started photography, the artist who made those early images seems so young and so, well … I was a beginner. So I'm not sure what to do with those negatives. They don't take up that much room, so I'll probably keep them. But the lesson here, I suspect, is to realize that creating artwork is a real-time thing, not a future thing. There's real virtue in finishing today's vision today, because tomorrow my vision will probably be different.

An Example of What Makes My Blood Pressure Rise

I received an email today—a mass email, I must admit—from a gallery. I'd like to share it with you just because it will help me make a point. It says:

Dear Collector,

Less than two years ago I had a difficult time getting people to buy prints by Diane Arbus at $4,500 even though I told them there was a major exhibition coming and the

work was going to drastically increase in value. Let this be a lesson. Lee Friedlander will raise his prices in the next few months. He doesn't want to give me an exact date because he doesn't want a flood of orders. And while they may not go up dramatically, many people—including MOMA—consider Friedlander the greatest living American Photographer. He should immediately move to the top of any collector's want list. So consider yourself forewarned!

And then it's signed by the gallery owner. This may be one of the most blatant examples of the silliness about pricing that I have ever seen, but it's certainly not the only one. The thrust of this message is that you're supposed to buy this artwork not because it's necessarily great; you're not even supposed to buy it because you like it; you're supposed to buy it because it's going to go up in price—because it's a great investment. The gallery owner is not selling artwork here, he's selling stocks and bonds; he's selling cattle futures. He's not doing anything that is helping photography. As a matter of fact, it's sort of a ridiculous proposition to begin with.

Lee Friedlander supposedly doesn't want to announce precisely when he's going to raise his prices because he's afraid he might get "a flood of orders?" A *flood* of orders? I'm sorry folks, I'm just not buying it. There's not going to be "a flood of orders" when you're selling work for $2,000, $3,000, $4,000, $5,000. We don't know precisely what the Lee Friedlander price is, but it isn't going to happen in a flood. I mean, they're going to sell a few; they're going to sell a few *to some very elite buyers*. But they are certainly not going to sell a flood of prints to people who might love Lee Friedlander but who are, shall we say, normal human beings with modest budgets to live on in life. This, to me, is just absurd.

Here's another way to illustrate the point: How many wealthy rock stars have been created in the last 30 years? How many wealthy movie stars have been created in the last 100 years? How many TV actors are doing extremely well because they are so talented?

Do you realize that the movie stars sell tickets for $7.50 apiece? The rock stars sell CDs for $10-$15 apiece. The TV people—their product is available for free (well except for cable)—but essentially it's free. And yet photography tries to create wealth and a market by insisting that the reason you buy it is that it's a good investment—and so therefore, pay a fortune for these things. It's a bunch of snake oil. It gets me in big hot water with the galleries, but I've got to call it as I see it. It's a bunch of snake oil. But when the galleries insist on pushing these prices higher and higher and higher and selling product based on the idea that it's an investment—well, it just locks out 98-99% of the population, and makes the rest of us frustrated because we can't buy original photographs. I guess we're just supposed to buy books and be happy with it. It's not a bad alternative, but the "let them eat cake" elitism of all of this just sticks in my craw.

I don't make this argument based on the idea of class envy; I make it because I think the elitist approach to selling artwork is ultimately destructive to our industry. It doesn't help the new photographers break in, it doesn't help the customers who want to own the product, it doesn't ultimately help the middlemen, the galleries and the distributors and the sellers, in fact, I don't even think it helps the photographer. I think it's silly. I think it's stupid. I think there's no other industry in the world that works this way, but it's wonderful for the egos of those who are involved when you can succeed at it. But ultimately, that's why I believe photography is a little teeny-teeny-tiny thing with a few thousand (maybe ten thousand at most) serious collectors, and why other forms of entertainment and artwork—like the music business and the movie business—have literally tens of thousands of creative people who are doing well and making money, and making a living at it. And why with photography—if you want to make a living at it—you better be doing weddings and portraits.

Sorry to all you galleries out there, but I've got to call it the way

I see it. And I think it's just silly. If you disagree with me, I want to see the argument that says it's great for photography that it be limited to only the wealthy elite who can afford to buy expensive artwork for the price that exceeds the average person's monthly take-home pay. I want to see you make an argument that says that is the good and solid foundation to build a healthy industry for our artwork. Because I don't think you can make that argument. At least I'm not aware of any other industry that makes a go of it by appealing only to the elite and essentially completely locking out the masses. It just doesn't happen. And it's too bad that it happens in photography.

Who Soups the Prints

One of the critical parts of the debate about digital photography has nothing to do with digital photography whatsoever; it has to do with mechanical process and whether or not photography is a hand-produced thing. There was a time, at least when I got started in photography, that we photographers were told and encouraged and essentially dictated to that *we* do everything. We exposed the film, developed the film, printed the film, cut the mat boards, and even put them in the frames most of the time. Somehow getting someone else involved in that process was a dilution of the creative task.

We knew that people like Ansel Adams had assistants, but they did so because they were so busy and so successful that they couldn't keep up with it all themselves. But we normal human beings were supposed to be the total creative process behind everything that we did, and to have someone else do our printing or someone else do our matting was somehow not quite within the bounds of what we were supposed to do. We were losing control.

This is a specious argument. We didn't manufacture the film. We didn't grind the lenses for our cameras. And so now all of a sudden this same argument has cropped up again relative to the digital world.

Somehow it's more mechanical when you just have your computer make a print of an image. Or somehow it's not quite right if you send your digital file out to have a new digital negative made. There's something supposedly too mechanical, too production-oriented about all of that.

But again, it's a specious argument, because somewhere along the line in the production of a photograph, someone else is going to come in to help us—some manufacturer, some third party. And I think it's important that we as photographers recognize that choosing our third party helpers is an important part of our creative process. There's nothing wrong with having someone else print your prints. I don't even think there's something wrong with having someone else set up the camera—which happens a lot in the commercial world. It's the creative vision that is the role of the artist. And that creative vision may or may not have anything to do with the mechanics of capturing the image on film or capturing the image in a digital camera.

Where we as creators should be involved is in the creation of a vision, and whether or not we are involved in the technical craft part of producing the image is our choice, but as a choice that means we also have the choice to let someone else do the craft part.

If you think this is odd, ask Richard Bensen about printing Paul Strand's work. Ask John Sexton about how he helped Ansel Adams. Ask Duane Michals about all of the printing that is done for him by other people, or Howard Schatz, or ask Ruth Bernhard about the assistance that Michael Kenna gave her.

It's the creative vision that counts, *not* who soups the prints.

Paul Strand, Galileo and the Ellipse

Throughout most of art history, the perfect shape, the divine shape, the celestial shape has been the perfect circle. That's the shape of a halo; that's the shape of the eye of God; and this is precisely one of the reasons that Galileo got in such big trouble. It wasn't just that he defined the Sun as the center of the solar system and not the Earth, but in doing so he insisted that the orbit that the planets traversed as they circled the Sun was not the circle, but rather the ellipse. He had discovered that the ellipse is the celestial shape—not the circle.

The ellipse is the shape that has movement, that has life. The best way I can illustrate this is paraphrase and Alan Watts illustration. Let me ask you to imagine a ball at the end of a string that you would like to twirl above your head. The shape that the ball traverses is not the perfect circle. As a matter of fact, you can't make a ball twirl around your head in a perfect circle. It has to be an ellipse. You've got to give it that little oomph—that *voomph, voomph, voomph, voomph. That's* what gives things life—when they're slightly off-center. And that sound, *voomph, voomph, voomph*, what does that sound like? That's the sound of a heartbeat.

You might ask, What does all this have to do with photography? Well, in exactly the same way, a photographic composition that's based on the circle—that's based on *dead center,* that's based on the very middle—what we call bull's eye composition, tends to be boring. There's no life to them, there's no movement, and that's why the best photographers who understand this principle tend to keep things out of dead center.

I was reminded of this because the other day I was looking at one of my books of Paul Strand's works. Look at *Un Paese*, look at *Tir a'Mhurain*, look at *Time in New England* and draw an imaginary X right through the middle of the pictures, and what you'll find in every case at dead center is *nothing*. All of the elements

of a Paul Strand photograph revolve around that center and that's one of the reasons, I think, his photographic compositions are so magical and so alive and he's such a wonderful photographer: He understands the principle of being slightly off-center.

If the Negative Really is the Score...

In every art form it seems there are some unspoken rules and regulations that you're just not supposed to violate. They are more like fashionable trends than they are societal laws, but nonetheless we seem not to violate that rule, and here's a good example of that:

In music there's a separation that takes place between the composer of a piece of music and the performer. Sometimes they are the same person; Joni Mitchell writes music and performs music. Carole King writes music and sometimes performs music, but more often just writes it. And then there are people like Irving Berlin who wrote music but rarely performed it, if ever at all, because he was a composer, not a performer.

So today in a concert hall we can have Mozart's Concerto in D Minor played by some orchestra and it's still referred to as *Mozart's* Concerto in D Minor because he was the composer. And this separation is taken for granted in the music business.

But in the photography business this is one of the major taboos. Photographers often go so far as to protect their negatives and either destroy them and burn them or lock them away so that no one else can print them other than themselves. But didn't Ansel Adams call the negative the score and the print the performance? But we never have "Ansel Adam's *Moonrise* as performed by John Doe," but we could. It's not an unknown idea in the art world. It's just a major taboo in the photographic art world for that to happen.

I'm not really sure I'm prepared to advocate this, but it is an interesting question: Why and how would photography change if we had this separation between the *creator* of the vision and the *performer* of the vision?

Recently I found myself wondering if someday I'm going to find a photographer who sells his or her Photoshop files so that people can print them at home on their desk printer. Instant art, just click and print; hmmm … now that's a weird one.

How the Medium Determines the Answer

A couple of years ago when I was remodeling the darkroom, I needed to build a new 12-foot sink. I was just going to build it out of plywood and paint it or fiberglass it. So this sent me off to try to find 12-foot plywood, and I was just striking out. I couldn't find 12-foot plywood anywhere. I figured somebody, somewhere has to make 12-foot plywood, so in frustration I called a friend of mine who I thought might have the answer. I told him I needed to find 12-foot plywood. He asked why and I said I was going to build a 12-foot darkroom sink. I was really frustrated because all I could find were standard sheets of plywood that were 8x4' and I needed to find a 12-foot piece of plywood. He said "Well, why don't you just build two sinks? Build one that's 8 feet and one that's 4 feet and that will add up to 12 feet." It was one of those slap-the-forehead moments. Why was I beating myself up trying to find this 12-foot plywood when the solution was right in front of me?

This illustrates, I think, one of the challenges that we have as artists, and that's not to confuse the medium and the message. Said another way, in my case, the question I was asking was determining the answer. And I think this pertains a great deal to the creative process, too—how many times the answer that we come

up with is predetermined by the question. If you want to write a popular song, you better write a 3-minute one, because that's what the radio wants—a 3-minute song. Another example: the ratio of a television screen is 4:3, and that means that all these movies that we rent have this warning that says, "This picture has been modified to fit your TV screen." Until somebody said, *"Wait a minute, why don't we just do wide-screen TVs?* Do a shadow box, have a little black band on the top and bottom, but that way you can see the whole thing!"

Sheet film comes typically with a 4:5 ratio if you're shooting 4x5 film or 8x10 film. But why do we have to shoot pictures that have that same ratio, 16x20? A friend of mine does fantastic panorama images on his 8x10 camera, but he only uses the very center piece of the film. He's not letting himself be limited by the format of the film. Why do we have straight edges on pictures? Why do we have quadrilateral pictures? Why not rhomboid shaped pictures, triangular shaped pictures, oval shaped pictures, etc.?

My point here is, *don't let the medium that you're using determine how you see. Let how you see determine how you use the medium.*

Taking versus Making

Do you *take* photographs? Or do you *make* photographs? There's a lot more to this than just mere semantics or polite language. *Taking*, of course, is an aggressive word; *making* is a much more passive and somehow acceptable word. But I think beyond this is an even more interesting idea, which is: What is your approach when photographing?

There are those people who look at the world and try to be sort of fly-on-the-wall observers to the world. "Let's see what's happening out there and then see if we can somehow make an image

from whatever is happening by capturing just the right moment at just the right angle." And then there are those who take a more participatory approach to the project by actually working to make something happen in the world that wouldn't happen without them being there—the sort of *constructionist* idea.

One of the things about photography that's so fascinating to me is that both of these approaches are perfectly valid. Unlike, for example, painting or sculpture, or even poetry or calligraphy—in almost all the other art forms *making* the artwork is clearly what is happening because you don't just run out and find a painting somewhere, you actually have to *make* a painting somewhere. You might construct a still life and then paint it, but it's not quite the same thing as it is in photography.

I think that's part of the confusion about photography, too, is the fact that the role of the photographer can be both objective observer and creator of something. I love this. I just wish it didn't so confuse the discussions about *Is photography art or is it not?*

The Perfect Photograph

I was talking to a fellow the other day who is not a photographer, but he's a very curious guy and he knows my passion for photography. He asked what sounded like a very naïve, even innocent question. He asked, "What do you consider a perfect photograph?"

Well, I have to admit I was a little nonplussed by that because it's not a question you hear very often. I had to think about it. And I realized that the definition of a perfect photograph can be a variety of different things. Is a perfect photograph one that's sharply in focus, one that has all the right tones? Or is a perfect photograph one that conveys the emotional intent of the photographer/artist?

Or is a perfect photograph one that creates a perfect resonance with the viewer so that he or she has a tremendous visual experience? Or is the perfect photograph one that leaves no question whatsoever about the content of the image so that all people get essentially the same thing? Or is a perfect photograph one that survives in time so that people 50 or 100 years from now will see essentially the same thing or the same meaning in it that we see today?

You get the idea. It's well worth thinking about—*what is the perfect photograph?*—because as I said a few days ago, the way you ask the question can significantly influence the answer. Quite honestly, I'm going to have to think about it some more, because I'm not sure what the perfect photograph is.

The Gift *by Lewis Hyde*

I've been re-reading a book that I discovered about 20 years ago and was very impressed with back then. It's called *The Gift: Imagination and the Erotic Life of Property,* by a guy named Lewis Hyde. Basically he discusses how gift-giving is a thing that's completely outside the normal thoughts about economy and commerce and trade—and how gifts have a magical property all their own.

As a photographer and a creative person, obviously this makes me think about what I could do to implement some of these ideas. When I first read the book 20 years ago, I sort of went on a gift-giving spree; I gave away a *lot* of photographs. And you know the most marvelous thing happened: I received a tremendous amount of positive feedback; I received encouragement; I received a bit of notoriety; suddenly I was known as *a person who makes photographs,* rather than a photographer. There *is* a slight difference between the two. And interestingly enough it eventually led to some exhibitions and it even led to some print sales.

Now, that's not the reason to give away gifts—to get all those things—but it is an interesting consequence. And that's one of the things he talks about: a gift to the universe that is given without any strings attached does tend to reap rewards as an unintended consequence.

So, here's an interesting idea: What do you suppose would happen if, for the next three months, you gave away ten prints a month? And, if ten is too many, what if you gave away five? And not to the same people—they had to go to completely different people—maybe even people that you're just acquainted with, that weren't just real good friends of yours. Not trading prints, just plain giving them away. I think it would be very interesting as sort of a research project, if you will, if I could get ten or fifteen or twenty fellow photographers to commit to do this for the next 90 days, let's say, and then report back what the results were of having done that. It'd be a fun little experiment. If you're interested in partici-pating, I'll do it, too. Drop me an email and we'll see if we can organize something.

Signing Your Prints

By sheer coincidence, in the last 48 hours, it's come up several times how we attest to our own work. I think it's an interesting question.

For example, authors have their own name typeset on the title page of the book or on the spine. Filmmakers have their name put up front in the title credits. Calligraphers do their own name in calligraphy at the end of the text that they've written. Poets do the same thing a lot of times.

Painters are different; painters put their signature right in the image conventionally in the lower right hand corner. It's usually

somewhat obscure but it's *there*, so that it can be seen. Sculptors, on the other hand, usually sign their work on the bottom edge - often on the backside - and they chisel it in or scrape in their name. And then there's lithographers who use pencil in the lower right corner just outside the image, but still on the paper.

In Japan, signatures are completely different. There they use what's called a *chop*. The Japanese term is *honko*. It's a small stamp that's typically carved out of soapstone or jade. They use this stamp to mark their work with red vermilion. In woodblock prints, sometimes the chop is carved right into the wood block.

So, how do we photographers do it? Well, I've seen all of the above. I've seen signatures in the lower right hand corner off the photographic image on the mat board. That's probably the most common. Occasionally I see someone sign right *in* the image. Occasionally it's on the back. Edward Weston signed it *low* on the mat board. Brett Weston did too, so you have to cut a separate window so you can see the signature. Some photographers insist on signing the photographic paper.

Then, of course, there's the whole question of digital artists? Do they put their *digital* signature right in the image or do they actually sign it by hand with a pencil?

I think it's an interesting question, but really, fundamentally, the most important part of the question is ... "What does it *mean?*" What does it mean when we sign a print? Does it mean that this photograph is *produced* by the photographer? Does it mean it's *touched* by the photographer? Does it mean it's *authorized* by the photographer?

I've thought about this a bit and what occurs to me is ... I believe that for most photographers it's simply a convention. They don't really mean anything specific other than this is *my* work somehow; it's ownership. But it's really a convention more than it is fraught with meaning.

For galleries, on the other hand, it's a marketing component

that is a big deal. And for collectors, it's a bit of a visible bragging point. *This is an original print* or *this is an original print by an important person*, if you can recognize the signature. I think this is one of the reasons why the digital signature is a problem for collectors because what does that mean to *them* relative to being an original?

The real question is what *should* the signature be? Where should it be? How should it be? I have no idea. I'm asking a lot of questions here and I don't have any answers, but I do know this ... for each of us involved in the creative life, it's a question worth thinking about and deciding for ourselves because how we choose to do it should be consistent with *our* intention and *our* sense of meaning. That's part of the story that we have about our artwork ... what our signature means.

I don't think there is any universally right answer, but I do think it's a universal *question*.

Artspeak

OK, it's time for me once again to feel incredibly stupid. I received a press release announcing an upcoming gallery exhibition. I get these all the time. Here goes.

The title of the gallery exhibition is called "Subplot":

Subplot brings together three New York artists whom at first glance seem to have very different agendas but share a common contextual terrain. There is an implied conspiracy on the part of the artists be it narrative, political critique and/or materiality. Escapism and fantasy permeates these works and are developed through the idiosyncratic way images and materials can be appropriated and transformed into something extreme. The artists eventually

question if fantasy can truly be escapist or even liberating. Whether making paintings of ice cream trucks, titans of commerce or abstract psychedelic these three painters engage in the complexities of our era, where absurdity, grandeur and chaos are celebrated and criticized...

(Sigh) Must I go on?

What the *hell* does any of this say? What the *hell* does any of this *mean*? And why do galleries (and artists) insist on this kind of convoluted, self-important, puffed up *artspeak* that seems to mean ... *nothing*? It's language with no meaning to it.

Is it any wonder that the vast majority of people in this world think artists are goofy intellectuals with their head up ... somewhere I shouldn't mention?

I don't know. I just shake my head.

Illustrated Letters

I've been reading a fascinating book called *Illustrated Letters: Artists and Writers Correspond* by Roselyne De Ayala and Jean-Pierre Gueno published by Harry Abrams.

The focus of this book is that artists of various kinds, usually painters, have had correspondence with their friends about life, but in these letters they've tended to make little sketches and drawings. Oftentimes these are the kinds of impromptu sketches that would take place maybe in a cafe or at the theater or some such thing. They write the letter—normal correspondence, like you would to a family member or a friend—about their life. Keep in mind this was primarily done in the years prior to telephones and etc, when letter correspondence was more common.

What struck me interesting about this, and the reason I picked up the book, is because I think there's some ideas there for those of us who are photographers. Photography doesn't *have* to be some-

thing that's a formalized snapshot nor a formalized piece of art-work in a frame. But why - particularly in this day and age of inkjet printers and whatnot - why couldn't we print a photograph or a couple of photographs and use that as a basis for a document to write a correspondence to someone?

What fascinated me about this is how special and how won-derful these letters were. They're so wonderful that somebody has taken the time to collect them and publish this book. They're re-ally very interesting, very entertaining, wonderful little impromptu sketches. Obviously sketches in the sense that they're unfinished artwork, because they're not *intended* to be artwork. They're just intended to be something fun.

I think photographers could do this. I'm gonna try it. Just thought I'd share the idea.

Photography is Not "About Light"

I had a conversation today with a fellow photographer in which we were comparing the Zone System to Postscript and Photoshop output, and how the differences in tonality don't quite translate from one medium to the other. We got involved in all the details about trying to measure gray, etc. It reminded me how often we photographers get so hung-up in this *technical* aspect of what it is that we're doing.

I once attended a workshop in which a very *famous* workshop instructor said the photography is "about light." I couldn't help but be thunderstruck by how silly that statement is. That's the func-tional equivalent of saying that novel-writing is about *words*. Or that poetry is about *fonts*. Or that music is about *notes*.

Good art, *meaningful* art, the *creation* of meaningful art, is al-ways **about life.** It's about humanity. It's about being a human be-

ing. It's about the human condition. It's about the struggles, the joys, the thrills, the disappointments of everyday life; that's what art is about. It's about God. It's about the supernatural. It's about relationships. It's about the Earth.

But it's not *about light*, because it's not about technique and it's not about tools.

There's no doubt about it, light is *the* important tool, but photography is no more about light than painting is about pigments.

The next time you find yourself staring at a photograph that just captivates you take a moment and ask yourself, is it the *tones* that you're interested in? Or is there something in there that just grabs your heart, makes the hair on the back of your neck stand up, gives you the goose-bumps, makes your heart go pitter-patter, excites you on a much deeper, emotional level?—not the *mere* tonalities.

At least in *my* opinion, that's what art is all about.

The Alternative Resource

If you're like me - and I like to think I'm a fairly typical photographer in this regard - I do get a bit of a thrill when the B&H catalog or the Calumet catalog or the photoeye books catalog shows up in the mail. I love looking for things that are related to my passion of photography.

Years ago a friend of mine taught me an alternative game that I have to admit has become just as fun, if not more so. It's the game I would call **the alternative resource**. The idea here is you go into a store that you would never normally go into. In my case that might be something like a fabric or a sewing store. Wander up and down the aisles and look at all the stuff they offer for sale and say "How could I use this in photography?"

That's where I found that embroidery hoops make the most

fantastic support structures for dodging and burning tools for use under the enlarging lens. Or you can do this at the hardware store where I found laser levels that are fantastic for making sure that the tripod head is perfectly perpendicular to a wall or some other flat structure when I'm photographing it. I buy white gloves for spotting and matting prints, and handling things carefully, from an online store that sells parade gloves to military schools and cadets. I buy vinyl gloves from an industrial supply house that I can use in the darkroom when I'm toning and I don't want to get chemistry on my fingers.

I love going through industrial catalogs, like Grainger, and saying "How can I take what they sell that has nothing to do with photography and use it in photography to make my life easier?" Maybe the product was never intended to be used by photographers, but it's amazing how many little gadgets and widgets and stuff that's out there that is perfectly usable for photography even though it was never *intended* for use in photography.

The alternative resources game - besides, it's Friday today, and if you have the weekend free why not go shopping?

Separating the World You Work in from the World In Your Photograph

I was out photographing this weekend and I remembered one of the great lessons of photography: how important it is to be able to separate out the *experience* that we're having as photographers, while we're making photographs, from the experience that *the viewer* will have when they're looking at the finished, final artwork.

In my case, this weekend I was photographing in an old World War I military installation called Fort Worden that's up on the

Olympic Peninsula, near the town of Port Townsend. This is miles and miles of cement walls that are now abandoned; bunkers and things like that. These have had an incredible amount of graffiti written on them over the years. The state park people come in and they paint over the graffiti to get rid of all this gross, really crude stuff and make it, hopefully, a bit more presentable for the public to visit.

Well, in the course of doing this painting over the graffiti, they aren't aware of it but they've made this fantastic abstract. Miles and miles of walls of abstracts. It's a fantastic place. I love photographing there.

But while I was photographing, surrounding me was this incredible chaos of literally 50 or 60 young boys running around, screaming at the top of their lungs, darting in and out of the rooms, playing soldier, fake shooting each other, yelling profanities and slamming doors. It was an incredibly noisy, chaotic environment. In addition, all the chaos of the graffiti on the walls that has *not* been painted has gross, seventh grade humor, sexual innuendo, and all that kind of thing.

In the midst of all that chaos, I found these wonderful, quiet abstracts. It was necessary for me to separate the *artwork* that I was trying to create from the *environment* in which I was trying to create it. In a perfect world we wouldn't have to do that. But in the practical world of photographers, it's a useful skill to cultivate.

Feedback About Your Work

So you've done the work and now you've got something to show people. You show it and you get feedback. What kind of feedback do you get? More importantly, what is your response to the emotional feedback?

Well, I've been doing this for thirty years and I can tell you there's two basic kinds of feedback that you get. One of them is not very constructive; one of them is *potentially* constructive.

The first kind is "I like it" or "I don't like it." This is the most devastating to us, emotionally, because you put all this effort into producing something and then someone doesn't like it. And if you really respect that person's opinion, then it's devastating because you *want* them to like it. That's part of the reason why you do the work and why you show it.

So what should your response be when someone doesn't like it? Well, this is a really delicate, double-edged sword because *maybe* the work is bad and you should listen to their advice and hear what they have to say. You just haven't hit the mark with it. Maybe the work is really good, but it just doesn't appeal to *them* because "beauty is in the eye of the beholder."

And so, I think when you get the "I like it" or "I don't like it" kind of feedback that one of the appropriate responses is to probe a little further.

What is it about this that doesn't work for you?

What is it that you would do to make it better?

That's a dangerous question, because they might tell you what *they* would do to make it better which turns it into *their* artwork and not *your* artwork. You have to be a little careful with that one. But nonetheless, finding out why people like and don't like something sometimes tells you a lot more about *them* than it does about your work.

You can learn something in the process. Remember, it's often like a mirror. When work is held up in front of someone for them to see, oftentimes what they see is a reflection of what it is that they are prepared to see, or what it is that they're conditioned to see, or what it is that they're predisposed to see. And so their response about your artwork often tells you a lot more about *them* than it does about your work. So, keep that in mind.

If I show a piece of work to someone and I think it's going to give them a feeling of nostalgia and what they feel is a feeling of violence, then I might know that somehow I missed the mark; that there were symbols involved in my work that I wasn't aware of. If I want them to be sad and they laugh at it, then I know that I missed the mark again.

As I mentioned earlier, this has to be tempered with an understanding of *who* it is that's giving the feedback and what their prejudices are. But, when your work consistently misses the mark - people are always laughing at your tragedies or always crying at your comedies - then you know that maybe there's something going on in your work that is not quite coming off the way it's supposed to.

The bottom line is *feedback is a very delicate thing*. It can tell you a great deal; it can also tell you *nothing*.

This is one of those cases where those of us who are supposed to learn from the feedback and *need* the feedback are also the ones who have to judge whether or not the feedback is worthy of learning from or being judgmental of us. So, the student has to be able to judge the teacher, as it were. If the student were qualified to judge the teacher they would be the teacher themselves. It's a Catch-22. It's a delicate balance, but it's part of the reality of being an artist: listening to what the world says to you about your artwork and seeing whether or not you're getting the response that you want.

Now, as people who *offer* feedback, this also tells us something about what *we* can do. When someone asks me about their work I never respond "I like it" or "I don't like it"—at least, not as my first response. What I always try to do is tell them what it is that I see in the work. What it is that the artwork it makes me *feel*? How it is that I'm *interpreting* that work? That's a *lot* more valuable feedback to them than whether I like it or I don't like it.

Another Museum in Financial Crisis

I hope this doesn't make me sound insensitive, but I'd like to offer some advice to another failing non-profit organization. In this particular case, it happens to be the University of California Riverside and the California Museum of Photography.

I got an email today from a third party. Originally it came from the Director there, a fellow named Jonathan Green, who is sending out a plea to people to write letters of protest. They are having a huge budget cut problem that's going to essentially cause the museum to close. I feel bad about this, because its really a terrific museum; they have a great collection and they've done some wonderful stuff. But here's the key paragraph from his letter that to me indicates the real nature of the problem:

" ... because of the University's belief in the museum, the generous support of the citizens of Riverside and the strong support from national and federal foundations and agencies ... "

The question is, what's missing from this? What's missing from it, quite simply, is the solution to their problem. They're currently experiencing a serious budget crunch that may cause the entire museum to fold, and this has been going on for some time. They talk in the letter about continuing cuts that started in the early part of the Clinton years in the early 1990s and it's sort of come to a head now, so they're asking people for support. I'm assuming they're trying to get additional money. But the question is *where does money come from* for such organizations?

Far too often, in the mind of a non-profit organization, money comes from the government; it comes from the taxpayers; it comes from people who have a great deal of money who are benefactors and patrons. It comes from people *other than* the place where all money always starts from and comes from originally, which is *the marketplace*.

Now, again, I hope this doesn't make me sound like a crass cap-

italist, but any university like this that has a wonderful collection has the ability to *sell* something. They can *sell* books, they can *sell* posters, they can *sell* reproduction prints, they can sell *something* that people want. To the extent that you can find a way to produce something that people want to *buy*, money is not a problem. That's why businesses exist—for the purpose of finding ways to produce a product that people are interested in exchanging for hard cash. That cash then can be used to run the organization. It's no more complicated than that.

But, how many non-profit organizations have we seen struggle (and a lot of them ultimately fail) because they do not participate *at all* in the market? As a matter of fact, a lot of them kind of look down at the market; they think the market is somehow beneath them. So, they're constantly fighting this cash crunch.

What I'd like to suggest is for non-profit organizations to figure out, somehow, how to include at least a *small* marketing component in their mission statement, so that they can use the *market* as a source of funding rather than taxpayer funds, rather than grant money and the kind wishes and deep pockets of other folks. There *is* a solution here if people want to take a look at it—if they can get past their prejudices. It's been the solution since the beginning of time. The solution is the marketplace and the source of *all* money, which is people like you and me who are interested in *buying* something.

I know this idea will probably grate on those who are driven by the non-profit mentality. But, I tell you, we better start thinking creatively or more of these institutions are likely to dry up and blow away. I for one am sad to see that, because they are terrific institutions. They just need to think outside the box when it comes to funding—and the market is the best source of funding there is.

Thinking in Sets of Three

There's an old business management phrase that says "Conditions Control Operations."

Said another way, if you change the way you ask a question you get a different answer.

Or alternatively, if you change the structure of the way you think about something, behavior will sometimes change as a consequence.

I relearned this lesson a number of years ago when I started a new Sample Print Program in *LensWork*. Those of you who read *LensWork* are probably familiar with fact that we offer three sample prints in every issue. These are primarily offered to give people a way to see, first hand, the quality of our *LensWork Special Editions*.

But, I have to confess, there was a secondary reason for me to do it. I knew that if I committed to a three-print sample program every issue, that every 60 days it would give me incentive to come up with three new prints. Sort of to keep my hand in - I want to keep photographing! This gave me a deadline, and there's nothing quite as motivational as a deadline!

So, I set this up to do three pictures every single issue and the most interesting thing happened. Suddenly I found myself thinking in terms of *sets* of prints, *multiple* prints.

Every interior decorator I've ever talked to has always told me that good presentations of artwork are always in odd numbers; three of something, five of something, not *two or four*. I chose three for this program.

And now, when I'm out photographing, I find myself *thinking* in terms of three. If I find something that's really going to make a great photograph, I immediately start looking for the two pictures that will go with it. So the *structure* of this program has changed

my behavior. I'm getting some really interesting sets (at least I think so) from an artistic point of view. I'm really enjoying the projects.

So, what I'm going to suggest is maybe there might be something here for you, too. Instead of thinking in terms of making *a* photograph next time you're out photographing, think in terms of making *a set* of three photographs that go together, that somehow are related or that somehow can be presented together. You'll find it's a very interesting way to think, and will change your work in the field and change the way you creatively think about the process of working with the material as you're out there making photographs. At least, I do. I thought you might find it interesting.

Be Careful What You Ask For; You Might Get It!

Now, I get to tell a little story on myself and somewhere in here I think there's a lesson.

I'm getting ready to do an interview with a fellow who happens to live in Israel. We've decided that we're going to do this over the telephone. I'm simply going to tape-record it and then we'll transcribe it for an upcoming issue of *LensWork*. In order to record this conversation over the telephone, I headed up to Radio Shack prepared to buy what I knew was a device that could allow me to do this. It's a little (you probably know what this is) suction cup thing that you stick to the earphone end of a telephone, and the other end of the cord plugs into you tape recorder. It can hear what's going on through the telephone and will record both sides of the conversation - a little telephone-recording adapter. So, I went up to Radio Shack to buy that.

Unbeknownst to me, that's 30-year-old technology and nobody uses *those* anymore. But that's what I'd gone up to buy. When

I asked the fellow for that, he said, "No, we don't sell those any-more." I was ready to turn around and walk out.

But then I thought differently and I asked a question "Do you have anything that will do the same thing." And he said, "Well, we *do* have a wireless phone recording controller." This is a little more sophisticated than a suction cup deal, but not much more expensive. You plug the headset from your cell phone into one end, and plug the other end into the tape recorder. You can then record while you're talking on the cell phone, and the quality is *phenomenal*. It's just *very* good. I was just blown-away by how good this is.

I almost didn't get it, because I didn't know it existed. I went in asking for a *product* instead of describing the *solution* that I wanted.

Sometimes I think we just might be our own worst enemy by pre-judging - particularly in these areas of technology - what it is that we need in terms of a *product* instead of focusing on what is it that we need in terms of a *solution*.

The Key to the Creative Life

There's something absolutely magical that happens when all the elements of a photograph come together to make just an absolutely perfect image. When the subject is just gorgeous and perfect, when the light is perfect, the composition is perfect, the equipment that you have at the time is perfect, your skills are perfect and the timing is perfect ... it's magical.

But, you know that so very rarely happens. Let's take all the great, lucky ones that we can - but in the real world, photography is usually a matter of some form of compromise. Let me give you an example of that:

I started being involved in the world of recording back in the

70s. I tape-recorded my grandparents and my children. I would always try to find the best recording equipment I could possibly get. Well, after 35 years of waiting for the perfect recording device, it showed up on my doorstep the day before yesterday. I've been having an absolute ball playing with the perfect, portable recorder. It's absolutely marvelous. But I am so glad that I didn't postpone recording my grandparents and my young children and my parents and the events of my life back in the 70s, 80s, and 90s when all I had available were primitive cassette recorders as compared to today's digital, high-tech, wonderful recorders. I'm so glad I didn't wait for perfection.

Strive for perfection, but be willing to accept excellence. It's not a bad rule of thumb. Even though, as an artist, I know I'd love everything to be perfect. Sometimes you have to be willing to make that compromise. And when perfection does happen - great. But in the meantime, don't let the *lack* of perfect equipment or perfect skills or perfect subject matter or perfect light get in the way of making photographs and creating something.

In my opinion, that's the key to the creative life.

Everyone Collects Something

Sometimes things that are obvious ... are just so incredibly *obvious*. And you can quote me on that.

Here's a good example. Last Christmas, I was visiting my daughter over the holidays and I noticed that she had a very large collection of movies on DVD. We got to talking about this collection that she had and in the course of conversation it dawned on us that virtually everybody we know collects *something*. I had protested that I don't collect anything, and she said, "Well, Dad, what about your photography books?" She was right! Then we talk-

ed about my brother who collects arrowheads. This evolved into a project where we developed a real quick little list of a bunch of people that we knew personally and asked the question: Do they collect anything? And we could find in every single case of people that we knew, that they collected *something*.

Now, what is so interesting to me about this, is how few people I know who collect *photography*. I'm not talking about museum-quality, historically important, expensive collectable photographs. I'm just talking about photographs as small things, as little artwork.

How could we strategically promote this with our *own* work for example? Could you develop a *collectable* series of products that you have, prints that you make, maybe they're small prints, 4x5 prints, contact prints, a Print-of-the-Month Club.. some idea like that?

If you want to see an interesting one, by the way, one of the more interesting ones I've seen of late is from Kim Weston who is Edward Weston's grandson. You can see his print-of-the-month club at www.kimweston.com. It's a very interesting idea. And I think the more we can do as photographers to promote the idea of collectable photography - not just buying a print, but sort of buying or committing to a *series* of prints so that we are literally *collected* by someone - is not a bad idea. It's worth thinking about.

How could we strategically employ this in our own work?

Go to kimweston.com I think you'll find his work and his ideas about this interesting.

When I mentioned that everybody collects *something* it also dawned on me that what people collect are *things* that are, shall we say, collectable. That is, not just that they are *worthy* of collecting but that they *can* be collected. And by that I mean they are *affordable*, they are *available*, they are *desirable*, and they are *within reach*.

That means that we are not talking about $500 photographs because for most people those aren't in reach. But, think about what

people collect. I mentioned my daughter and her DVDs - that are $10 or $15 apiece. Some time ago I know it was all the rage to collect those little spoons when you traveled around the country and those were inexpensive. Some people collect T-shirts, or beer mugs, or whatever.

Now, I'm not saying that photography ought to be down-graded to some kind of little craft like that. What I am saying is that if you make a photograph and you insist that it's going to be some gallery-priced $500, $1000, $2000 or something, it's not going to be *collectable* by the very nature of what it is.

On the other hand, if you can define something that is collectable that you can make photographically, that is affordable, that people can fit into their budget, and are willing to collect, this might be a real key. How to do this might take a little bit of thought. But, I think if you're going to work on this idea of developing an audience who will collect your work, you have to keep this in mind … that the work needs to be within their grasp. Otherwise, you're not going to have an audience who *can* collect your work.

And by the way, what if that audience is ten people, fifteen people, twenty people and you're going into the darkroom on a regular basis, every month, every other month, once a quarter, something like that, and making something that is collectable for those people? Start multiplying that out. How many prints do you have, as we say, "in circulation" at the end of a two-year, five-year, ten-year period?

I think you'll find there's an idea here for getting your work out that's really worth thinking about.

Web Presses, Sheet-Fed Presses and Image Quality in Magazines

I was just reading in one of the chat groups I monitor a sad story about a guy who had one of his photographs reproduced in a magazine. It came out very badly and he was very disappointed because it didn't look right.

There's a reason why magazine reproductions sometimes don't come up to speed, and it has to do with the press. Magazines are usually printed on what is called a ***web press***. This is the kind of thing you see in the movies that print newspapers where the stuff is flying at a zillion miles an hour and coming off the end just in *truckloads* of paper. That's one kind of printing. It's a very inexpensive way to print. It's a very *mass production* way to print, but it leaves very little control in terms of trying to influence the quality of the imagery.

The other kind of press is what is called a ***sheet-fed press***. Web presses use big rolls, like giant eight foot tall rolls of toilet paper, except it's printing paper - newsprint or whatever.

A sheet-fed press uses individual sheets of paper and they are much higher quality presses. You can really control and finesse the way the ink goes on the paper and *that's* the kind of press we use for *LensWork*. And that's why *LensWork* looks different from the average magazine. Not only are we duotone (most magazines are just a black ink) and we have two inks (which is one of the advantages of doing a sheet-fed press) but the quality of a sheet-fed press is just much, much higher. All *good* books—all art books, all fine photography books—are printed on sheet-fed presses like *LensWork* is. That's one of the fundamental differences.

So, keep that in mind next time you have one of your images reproduced in a magazine somewhere. If it doesn't come out quite exactly like you'd like it to look, that's probably why. It's inherent in the nature of the technology being used to print it.

Duotone Printing

In yesterday's comment I mentioned that *LensWork* is printed with a duotone process. I had a reader email me asking for clarification on what a *duo*tone is.

In the process of printing on a sheet-fed press, the ink that is laid down on the paper is controlled by something called a printing plate. The plate gathers the ink off the ink rollers and then lays it down on the paper. If you do just normal printing—what is called half-tone printing—you have one ink roller, one ink-receiving plate which transfers one layer of ink to the printed page. That's it.

But, with better presses and careful craftsmanship, it's possible to lay down more than one ink on the same sheet of paper. You can have a press that has, for example, two printing plates, two ink rollers and lays down two layers of ink in sequence to one another. This has to be done with extreme precision so that they are in perfect register. Otherwise you get sort of a fuzzy-looking image. Good quality presses run by quality craftsmen have the ability to do this. As a matter of fact, presses can do as many as six ink colors at once. These are six-head presses, if you will.

The key advantage of doing duotone is that when you're using two *different* inks to create a *single* image, you can mix and combine those inks and have a certain tonal shift. A lot of the images in *LensWork* are slightly warm-tone as a result of that. The second advantage is, in my opinion, even more substantial. Black ink, when printed fully on the sheet to absolute maximum black, is not as black and solid as you'd think. Look at it with a loop or a microscope and you'll see it's just a bit mottled. There are some *thinner* areas. When you print duotone, the second application of ink from the second printing head overprints those black areas a second time and makes the blacks go *really, really* black. It's that extra black that makes duotone images just jump off the page, the extra dynamic range.

Duotone ink is where black and white photography *really* comes into its own.

So that's what duotone ink printing is. Printing a *single* image with *two* colors of ink and a double pass.

Goals

So here it is Monday morning and I'm wondering what I'm going to accomplish this week in photography - and I realize that I've got a problem.

I can best illustrate the problem by quoting from a great motivational speaker, Zig Zigler, who said that he could out-perform any Olympian archery champion in a contest to hit the bull's eye. He could out perform any one of them; he could, in a contest, he'll beat any one of them, any day of the week, any time—provided, of course, that you blindfold the Olympian archer and spin them around several times and make them shoot at the target blindfolded, not knowing where it is or what it is.

Of course, that was his clever way of illustrating the point that *without a concrete and clear objective, it's pretty tough to be successful.* Success is always defined against some goal or target.

This is standard business fare and I'm sure a lot of you have heard this kind of stuff before. But you know, I find it true in photography, too. Photography is a *creative* act and I tend to want to take it outside of such mundane ideas as motivational speakers and business practices. But as has often been said: creativity is 90% perspiration and 10% inspiration. I think this perspiration aspect is what I'm getting at here.

Every single week I *try* to have in mind something that I'm going to accomplish by the end of the week. I'm either going to photograph, I'm going to print, I'm going to organize, I'm going to

research a project, I'm going to read something, I'm going to search for something on the Internet. There's always something going on. I'm going to learn something, etc. And this week—here I am on Monday—I don't have a single objective. Clearly, with that in mind, I'm not likely to accomplish anything this week.

So, I guess I better get busy because the first step is to figure out what I'm going to do so that I can be successful doing it.

Ryoanji

I suppose most of you are at least somewhat familiar with the concept of a Japanese rock garden. These classic Zen gardens are usually large expanses that contain nothing but rocks or sand or pebbles and a few large boulders. The small sand and pebbles are raked on a daily basis. They are very austere.

One of the most famous is a garden called Ryoanji in Kyoto, that was built in the fifteenth century. I was reading about this particular garden in preparation for an upcoming trip to Japan I'm making this fall. It consists of fifteen irregularly shaped rocks of varying sizes, arranged in a bed of white sand that is raked every day. I've been to Ryoanji before, about ten years ago, and one of the things that is fascinating about these fifteen rocks is that no matter where you stand, you can't see more than twelve rocks at a time. The last three rocks are always to be comprehended through imagination. And this is considered one of the genius aspects of Ryoanji.

I remember when I was standing in Ryoanji thinking about this. How this is very, very similar to the process of looking at a photograph. We never see a photograph all at once. Our vision doesn't work that way. We have two kinds of vision: spotlight vision and a sort of floodlight vision. The spotlight looks at the de-

tails; the floodlight sees in the periphery but it doesn't see very much detail there.

When we scan a photograph our eyes tend to flit about. We even create a predictable pattern that people have studied. But we have to look at all the parts of a photograph *and then assemble it in our mind's eye*. I think this is one of the fascinating things about good artwork, it always brings forth that element of imagination and requires you to use your *mind* to really see it because your *eye* can't possibly see it all.

This is one of the things that I love about art; that it is, when done right, so engaging to a person's mind.

Some Things Change, Some Stay the Same

I was thinking the other day how many things have changed in photography, particularly with the new digital tools that I'm using more and more frequently. I've been thinking how things have changed from when I started in photography. Here are a few examples:

When I used to go out in the field, I worried incessantly about whether or not I had enough film with me. Now I worry about whether or not I have enough batteries.

I used to expose for the shadows and develop for the highlights. Now, with the digital camera, I sweat bullets over whether or not I'm exposing correctly for the highlights and I kind of let the shadows take care of themselves.

I used to pre-visualize for tones in the zone system. Now I find myself pre-visualizing for Photoshop filters and effects.

I used to try to speedup my handling of the camera and slowdown my thinking. Now I try to slowdown my use of the camera and speedup my thinking.

I used to worry about dust getting into my film holders. Now I worry about noise getting into the shadows.

But the one thing that hasn't changed, and probably never will, is the most important question I ask in the creative process. To paraphrase Edward Weston, "Is this the *strongest* way of seeing?" And I would propose that *this* question—which is the *key* question in photography in my opinion—this question still pertains, whether the bulk of the creative vision is made with the camera, or in the darkroom, or on the computer.

It's Just What You Get Used To

I had an opportunity this weekend to do something I haven't done for a long time. I printed some 8x10 prints on 8x10 paper.

Now, I have to tell you I haven't handled 8x10 paper for years. Most of the work I do is either on 11x14 paper or 16x20 paper. The 8x10 paper felt so small; it felt puny. But I remember a time in which making an 8x10 was a big deal; it was a *big* print. Buying and having and using 8x10 paper felt like doing something *real* as compared to the little 5x7s I'd been doing. So, it's simply a matter of what it is that you are used to as to whether or not it's a challenge. An 8x10 used to be a challenge and now I just think of it as being small.

I'll give you another example. I don't mean to use this example as a way of bragging or anything like that, so please don't misconstrue what I'm about to say here; but we're just wrapping up the production of the Bradford Washburn folios that have required us to print and finish about 1500 prints—processed to archival standards, selenium toned, individually spotted by hand—1500 prints! We're doing it in about … it takes about three weeks, three and a half weeks, to wrap up the entire project.

Now, there was a time in my life where I took six weeks to print a hundred finished prints. I've written about this in a previous issue of *LensWork*, and that at the time was a *huge* deal. A hundred prints in six weeks was more than I had ever done. Now we're doing fifteen hundred prints in about three or three and a half weeks. It's just a matter of what you get used to and I think that's an interesting thing to think about when you're faced with a *giant* project. It's only giant because you're not used to doing it, but as soon as you do it and you move on and you do bigger projects, more substantial things with bigger commitments and larger budgets and etc ... it's funny how the perspective changes on these things.

So, I don't know why I find that so fascinating but I do. Because I'm convinced that what is a big project to me now at some point and time I'll look at it and say, "Eh, that's not so hard."

Meritocracy and Grant Programs

Whether we're aware of it or not, all of us have certain presumptions that tend to rule our lives. These are often things that we learned in childhood. In my case, my dad was very athletic and a coach. I was raised in an environment in which one of the fundamental premises of life was the idea of *meritocracy*. People who work hard, study hard, practice hard, and then mix in a little bit of talent, succeed. Merit always rises to the top.

That meritocracy I grew up with has leaked over into my artistic and photographic life. Even though athletics and art have so very little to do with one another, the premise of meritocracy that I grew up with still continues to rule my thinking. I tend to think that the photographers who work the hardest, study the hardest, and practice the hardest are the ones who are going to succeed. Eventually, their merit will shine through.

This is precisely one of the reasons why I have, for years, been very suspicious of grant programs. Speaking honestly, grant programs are almost never about merit. They're almost never based on who really *deserves* to receive a grant. Instead—and this is the dirty little secret about grant programs—every grant program has an agenda, usually some political or social agenda, they want to promote. They want to get their message across. The people who get the grants are those artists who are most likely to further the granting organization's agenda. So, just be aware of that when you apply for a grant. If you receive the grant, you are, to a certain degree, being used as a tool to further the objectives of the organization that has the cash. They are buying something, and what they are buying with that grant is your ability to carry forward their message.

This, in my mind, is exactly the opposite of meritocracy. In a true meritocracy, the best photographers, the best artists, or the best athletes rise to the top because they've earned it, not because they can be used by the folks with the power.

Meritocracy and Publicity

Continuing on with the theme of meritocracy, I want to talk about Bonnie Raitt. I really like Bonnie Raitt's music. I've liked her music since the 1970s. But she toiled away as an obscure musician for years and years—for decades, really—until suddenly in the 1990s she got very popular. She won a couple of Grammy awards. She had a couple of albums that did incredibly well. And in one of her interviews about those albums she said, "You know, I'm the classic thirty-year overnight success."

What a great line!

She exhibits the difference, in my opinion, between *meritocracy*

and *publicity*. She spent 30 years or so developing her skills, developing her musical abilities, playing, practicing, growing, maturing. When she arrived at commercial and financial success, she did so because she had earned it.

Compare her to a lot of the musicians today who have very little talent, very little musical ability or skill, but who do have *fantastic publicists*—people who can get them on the magazine covers, get press, get coverage, get ink, get them on TV shows, etc.

Today there is a manipulation of meritocracy by people who are interested in fame and fortune without having to earn it. And that, I think, is a dangerous thing for society. It is a particularly dangerous thing for photography. It hasn't really been an overwhelmingly influential part of photography up to this point, but in the last ten or fifteen years I've started to see more and more so-called "superstar" photographers. Often they are ones who make what are, in my opinion, really lousy photographs. They do, however, have fantastic publicists. With nothing to show of merit, they're suddenly all the talk, all the rage; they're the new hot collectible artist, they're the auction record-setters. I just shake my head and hope there is still a place in this world for good old-fashioned merit—as opposed to buying your way into success.

Meritocracy and the World of Changing Standards

I've been talking about *meritocracy*. One of the problems of meritocracy is that it assumes there are standards—a common measure, if you will—by which various competitors can be judged.

The weakness of meritocracy in our day is clearly exposed in one of the most influential books I've read in my lifetime. It's a great book I recommend to everybody: *The Third Wave* by Alvin Toffler.

Alvin Toffler, you may remember, made his claim to fame with the book *Future Shock*. This subsequent book, *The Third Wave*, is part of the same trilogy. In it, Toffler discusses how society is breaking into tiny niche groups. He calls it the "demassification of society." As we separate more and more into sophisticated niche groups, the idea of a common thread or a common standard is breaking down.

I think there is some truth to this. After all, I publish *LensWork*, which is an extremely niche market publication. It's not really about photography; it's not even about art photography. It's about fine art *black and white* photography. So, I understand the concept of niche very well. The problem with any discussion of meritocracy is that everybody has a different way of thinking about what is meritorious. If you've been through an MFA program recently, you're going to think differently about what makes a great photograph than if you were from a traditional West Coast landscape school. These are two completely different worlds. That's why the people who love Ansel Adams' work maybe don't love Nan Goldin's, and vice versa.

One of the reasons I bring this up is because the idea of niche marketing means that any given style of photography, communication, poetry, art, product, *whatever* in society—and this is Toffler's great theme—is going to appeal to a relatively narrow group of people. Nowhere is this going to be more true than in photography. I think Ansel Adams was the last great universally enjoyable photographer because he happened to rise to popularity right at the time when we were at the peak of mass communication.

Look what's happened to the classic mass communication medium: television. We went from three major networks to two hundred channels on cable TV. Look at what happened with the Internet; look at what's happened with publishing! There are so many choices, and all of these choices indicate how the world of niche marketing has grown.

So, meritocracy (yes, I still believe in it) is defined by one's ability to be meritorious to a relatively small group of people who share a common set of values. That's why I think it's not a bad strategy to figure out what you're interested in doing photographically and then find the audience who loves your work. Forget about being popular beyond that; it's just not likely to happen.

The Third Wave by Alvin Toffler. Read it—it's a really great book.

A Legacy in Our Photographs

I'm currently reading, believe it or not, Winston Churchill's *History of the Second World War*. It's an absolutely fascinating six-volume set—hence, just a little slow going. The reason I bring it up is because I had a very interesting experience the other day while reading this book. All of a sudden it occurred to me that I was *hearing* Winston Churchill inside my mind, and I became fascinated with the wonder and the marvel that a book is.

The more I thought about it, the more it occurred to me: What a marvelous thing a book is! Think about the absolute wonder of the written language: this person who's now long dead wrote the ideas in his mind, which were then published in a book, which was then distributed into the world, which found its way into my hands—and those ideas that were in *his* mind are suddenly in *my* mind. What an absolutely fascinating thing that is! It's so simple, almost mundane, to speak about it this way, but it really is a form of magic that the thoughts in his mind, sixty years ago, can be fresh in my mind today.

What I find so fascinating is that this is essentially the same thing that takes place in photography. What I see and photograph today, what I produce today as a print, a book, or a poster is going

to survive (we hope, anyway!) and be someone else's vision fifty, sixty, maybe a hundred years from now. They will see through our eyes. What an absolutely fascinating, magical, spectacular, wonderful thing that is!

We should never forget as creative photographers that our creative vision may survive us by tens or even hundreds of years, and that what we are creating is not just a photograph, but a legacy of our minds and our creativity.

Resistance to Change

In 1774, a Japanese doctor named Sugita Genpaku found himself in possession of the first Western anatomy book ever to be introduced into Japan. He studied the anatomy drawings in the book—a science which had been totally foreign to Japanese medicine. He was fascinated by what he saw. In the drawings, he realized that all the medicine that he had been practicing to that point was obsolete in light of this new idea about the human body and about medicine. He petitioned the Shogun for permission to do an autopsy on a cadaver and learn for himself about the inner workings of the human body. He was allowed to do so, and it started a revolution in Japanese medicine of mind-numbing proportions. Many of the doctors of the day had never heard, never conceived of such a thing as the anatomy of a human being. As they studied this and learned more, they realized this was the key to understanding a great deal more about how to cure people and how to help people.

At the same time, there grew in the Japanese medical community a tremendous resistance by other doctors who continued to insist that Western medical practices were heresy. They insisted that Western medicine was a waste of time, that there was nothing to

learn there, and that, in fact, such practices and such books should be banned and not allowed into Japan. But Dr. Genpaku insisted. The genie had been let out of the bottle, so to speak, and Japanese medicine has progressed ever since.

The parallel between the old school of photography (shall we call it) and the new wave of digital photographers reminds me of this debate. A new technology—one that won't necessarily replace the old technology, but certainly has something of merit to offer—is being resisted by so many people who are steeped in the traditions of film and chemical photography. Why resistance to change is such a universal part of human nature is a great mystery, at least to me. But there's no question that it *is*, as we can witness by the fact that exactly the same resistance that took place in Japanese medicine in 1770 is taking place in 2004 in photography.

Abstracts Don't Sell

I have some advice for you if you're looking for subject material. It's real simple. *Avoid abstracts like the plague.* They just don't sell. There's something about an abstract photograph that is just very difficult to connect to the market.

Now, having said that, I have to confess that I personally *love* abstracts. There's just something magical about a great abstract that *speaks* to me. I'm not sure what it is. I *love* a great chord in music—just the wonderful harmony of a chord, even if it is without melody. Speaking of harmonies, I love *singers*, who sing in two-, three- or four-part harmony. It is just so mesmerizing.

That's part of what I love about abstracts. It's not the symbolism; it's not the metaphor. It's the simple *chord of tonalities*. When certain tones are put together, the thing just *hums*. Such tones just makes the hair stand up on the back of my neck.

Now, I wish the rest of the world felt like I did. It'd certainly be easier for me because then I could produce all the abstracts I want to produce and I'd have an audience for them. But the reality is, at least from my experience here selling *LensWork Special Editions*, and my experience in photography, abstracts don't sell.

So just do them for yourself! Find a few people who love them and feel grateful for it. But if you want to *sell* photographs, stay away from the abstracts. They just don't work.

Isn't that too bad?

Organization

My methods may not work for you—and of course, your methods might not work for me. So, it's a little difficult for me to try to be too dictatorial, even about an idea that I feel strongly about. Here's one, however, that I do feel strongly about.

It's the value of organization.

Creativity is a very difficult thing. It consumes a lot of energy. It takes a great deal of focus. It's not easy to be creative, but my experience is that it is infinitely more difficult when life around you—that is to say, your darkroom, your organizational skills, etc.—is complicating the issue by making it problematic for you to work.

A classic example of this is how you store your negatives or your files on your computer. If you have an organized filing system, when you're looking for a negative you can find it, and when you're looking for the printing notes on that negative you can find them. This makes the creative process of working with that negative so much easier. If, on the other hand, a whole lot of your energy is spent running around looking for a negative, or if you can't find it because it's buried in a pile of stuff, in a box, or lost in a cabinet

drawer somewhere, it's very difficult to be creative. My creativity is enhanced when I'm organized and my darkroom is clean, my desk is uncluttered, and my schedule is clear.

It just makes the process of being creative easier. My creativity can blossom in that nice clean slate that starts with organization.

Mundane Events and Things

There's an old joke in photography that says, "If you can't make a spectacular image of a mundane subject, then at least make a mundane image of a spectacular subject." I think this is why a lot of people run off to Yosemite or some spectacular sunset somewhere. Even a bad image of a gorgeous subject is a reasonable photograph.

But the interesting question is, "Why is it so difficult to take a great photograph of a mundane subject?"

Bill Jay once commented to me that in all the years he taught the history of photography at the university level, he never had a single student present to him a portfolio of life on the university campus. I guess it was just too mundane. What this means is not that it's difficult to photograph mundane things, it's that it's difficult to see them as significant.

I've been thinking about an interesting idea of late. I don't know that I've read this anywhere; maybe I did read it and I've just forgotten. The idea is that there are only two kinds of photographs: there are photographs of things and there are photographs of events. Either something's *going on* that captures your eye, or there is some *thing* that captures your eye; and if it's not one of these two, it's pretty tough to make an interesting photograph of it. If there's a thing, but the thing itself isn't very interesting, it's difficult to see

it creatively. And if there's an event that's common—nothing un-usual about it at all—that's difficult to make a photograph of, too.

I think this is one of the reasons why all landscape photogra-phers really lust after those gorgeous, beautiful moments of weath-er and cloud, sunlight or fog. Such drama in the weather turns a thing—say, a hunk of land—into an *event* that's suddenly worth capturing. By the same token, we can make a portrait of very or-dinary people doing very extraordinary things—bucking bronco cowboys, for example: rather plain-looking people doing some-thing very exciting in an event. The hard thing to do, of course, is to find a way to photograph a mundane subject or a mundane event in a way that makes it exciting. Maybe that's just too difficult to do. Maybe it isn't worth doing. Somehow, the fact that it's really diffi-cult seems to me to make it a fun challenge. I guess when someone tells me something can't be done, it immediately motivates me to try and prove them wrong and do it.

Being Introduced as a Photographer

Not long ago, I was attending a social event when a friend of mine introduced me to another person by saying "Let me introduce you to Brooks Jensen, he's a photographer." I cringed. I knew what was coming next. Sure enough, the person I was introduced to got all excited and said, "Gee, my daughter's getting married next month and we're still looking for a photographer. Maybe you'd be available?" Ouch. I had to explain that wasn't quite the kind of photography that I do.

I'm sure my experience here is not unique. I'll bet you've had a similar experience when you've been introduced as a photographer. People will make all kinds of assumptions about what you photo-graph.

Once, when I was introduced to a whole circle of people at one of these events, the conversation immediately turned to "What kind of photography do you do?" I said, "Well, I'm a *fine art* photographer." I then received all kinds of advice—where to go to get a gorgeous sunset, or the pristine mountain lake photograph. Ouch again.

It took me a long time to think this through, but I think I know where it comes from. It has to do with simple semantics. If you explain to someone that you're a writer, the first thing they're going to ask is, "What *kind* of writer are you?" Or, they might ask, "What do you write?" You can then explain that you're a *journalist*, or a *newspaper reporter*, an *advertising copy writer*, a *novelist*, a *poet*, a *playwright*, or a *screenwriter*. There are all these terms to define what you write. But, if you say to someone that you're a *photographer*, they don't have a way to ask about it. We don't use the word "portraitist" or "landscapist" or "still-lifeist." Those terms sound sort of silly, so *photographer* becomes a catch-all term.

I've come to conclude that when I'm introduced to people as a photographer, I know they're going to misunderstand what I do with my photographs. I've turned this into a positive by recognizing it's just an opportunity to show people my style of photography by showing them my photographs—which is not such a bad way to get introduced, after all!

Images on the Monitor or TV Screen

As most of you are probably aware, we are working a great deal these days on the *LensWork Interviews,* our DVD programs. I had a fascinating observation about this, which has to do with looking at the images on the TV screen as compared to looking at them as prints or as images reproduced in books.

I have to tell you, I'm really falling in love with the way a black and white photograph looks on the TV screen. They look fantastic! It's taken me a while to figure this out, because I wouldn't expect photography would look so good on a television screen. Obviously, it can't possibly be as high a resolution as a print or a reproduction in a book—or so you would think. But there are two things about looking at an image on a screen that compensate for that.

First is that the image is so doggoned big! In a book, an image might be 8x10" or so. That's a perfectly appropriate size for an image in a book. I actually like small prints, an opinion I've stated before. But when you look at an image on a TV screen, you can't help but realize that what you're actually seeing is an image that's closer to 16x20". In some regards, that really does make an impressive photograph!

The second thing that's undeniable is the fact that since it is essentially a backlit image, with the light coming from behind, there is an incredible dynamic range—an incredible sense of light that shows up in the photograph.

I noticed exactly the same thing when I'm looking at images on a computer monitor—whether on websites or CD's that people send me. The images on a computer monitor look fantastic!

In my case, I have a fairly large monitor—a 21" monitor. The images I see are roughly the equivalent of an 11x14" print. An 11x14" image that's backlit the way computer monitors render light tones and dark tones really gives you this tremendous sense of dynamic range. It's a wonderful way to look at photographs. Sure, it will never replace original prints—and they still hold a soft spot in my heart. I love original prints; I love high quality printed books; but, I have to admit that the computer monitor and the TV screen as methods for looking at photographs are actually growing on me for some of the advantages they have. It's a *different* experience, but nonetheless, a high quality one.

Daily, Focused Discipline

A friend of mine sent me the following e-mail, which I thought I'd share with you exactly as it arrived. She wrote:

Brooks,

This came to me while I was listening to your CD of blogs. You got me thinking about photography as art, and how it's not unlike other forms of art in so many ways. I've often had this thought about some of the interests that I've pursued. At the center of my thoughts was the notion of *discipline*. I observe it in my husband every day. He might not call it discipline, because he enjoys what he does so much. Somehow "discipline" denotes something that might be uncomfortable. But, he is practicing his art with discipline. He's lucky, because he learned early on at the piano that his playing would improve with daily, focused practice. Today, and every day, he pursues his passion of photography with that same focus. I believe that it is a part of him now. Again, he might not even define it in the same way as I do. You know what I mean though; even great athletes do it. They stay in shape and continually work on improving their form through their daily practice. And while I've pursued music or art or even swimming, I can see the improvement if I practice daily in a focused manner. And so I got to thinking about how important it is to stay *in shape* for photography. There are many facets to staying in shape for photography—seeing and taking the picture, developing the image, printing out that final image. All of this ought to improve with the practice of focused discipline. Finally, for me, I find that immersing myself in whatever I'm pursuing by reading all that I can about it; by being accountable to a teacher; by having conversations with others who are pursuing the same interests as I; these activities

enrich my interest in the subject. Through this enrichment, I'm aided in focusing my practice which in turn causes me to improve. All this ultimately snowballs so that I look forward to the practice, and ultimately the practice becoming a higher priority in my life. Discipline. Maybe you have some thoughts on it, and how this relates to photography. Hope all is well.

And then she signed her name.

Well, I don't think I could have said it any better. Thanks!

Warm Tone Prints

I consider myself a pragmatist: someone who judges things by whether or not they work, rather than by a theory about whether or not they *ought* to work. In my photographic career, I've found no better example of this than a story that was told to me by Oliver Gagliani before he passed away.

We were talking about print quality and he was telling me about how, when he was a young kid, he studied the violin. His father wanted to buy him a violin, and they had an opportunity to choose between two different violins. They took them out into a field and moved farther and farther away as the violins were played. This way they could tell which was the better violin by which one carried farther. Later in life, he had translated this into a way of judging print quality, too. He would take two prints and set them up across the room and get farther and farther away from them to see which one *carried* farther, to find out which one continued to look great when seen from a distance. I've had a similar experience, but in my case it's with warm-tone prints.

The tradition in black and white photography for a long time now has been to do traditional black and white silver gelatin imag-

es, selenium toned to a nice, neutral black—maybe even a slightly purplish-black, which often happens to a selenium toner. But I discovered years ago that I really don't like that color print. I don't like the natural greenish-black that you get from an untoned silver print. I'm not all that fond of the selenium toned purple print, either. I discovered, more or less by accident, that a warm-tone—brownish, approaching brownish-red but not deeply into the red, just approaching brownish-red—to me, is absolutely fantastic.

I think I have figured out why. To my eye, and I think I'm not the only one who would say this, a warm-tone, brownish print is more three-dimensional. It's that simple. If you don't believe it, do the test. Do a nice warm-tone brown print. Use something like Kodak brown toner, or a warm-tone paper with a fairly aggressive selenium tone. Compare that to a traditional cold-tone paper. Set the two prints up next to each other and look at them. Look at them from a distance, like Oliver did, and I think you'll find that the warm-tone prints probably do just look more *alive*, more three-dimensional.

When I first started doing this, people accused me of wanting to make "old-looking" prints. That has nothing to do with it. It's not the sepia *aged* look that's of interest to me. It's that three-dimensional *alive* look that I find so magical.

Explaining Artwork is Not Necessarily a Bad Thing

I'm fascinated by how the oddest things will just happen to come together and offer a lesson that can be used in photography. Here's a good example of that.

By sheer coincidence, I happened to be working my way through a couple of books that seemed to be, essentially, totally unrelated.

One of them is called *What Great Paintings Say* by Rosemarie and Rainer Haggan, published by Taschen. It takes great paintings and dissects them, explaining what is in the painting that was meaningful to people, say, in the Renaissance. It explains what they understood in those paintings that we, today, may not. The second book I'm studying is *The Annotated Shakespeare* by A.L. Rowse.

Don't ask me why I'm reading these two books—I'm just trying to fill a couple of holes in my rather pallid education. Both of them are essentially doing the same thing. They are explaining to me, today, in our age, what great artwork meant and said in a previous day—what the symbolism was, and what the assumed backgrounds were that helped people understand those pieces of artwork in their day.

My first thought, of course, was that it's nice to have these books and historians to explain all of this to me. I also thought how thankful I am that we don't need to do this in photography. It's all straightforward and relatively understandable. Then I thought again: *This isn't right!*

Here is a classic example: the photograph *Child in the Forest, 1951* by Wynn Bullock. This is one of the prints we offer as part of the Bullock Estate Images in the *LensWork Special Editions Collection*. This image shows a very young Barbara Bullock when she was (I'm guessing) five, six, or seven, lying in the woods. She's naked, lying face down in a bed a very soft looking, clover-like plants. It's a tranquil, placid, sort of fairy-like scene. At least this is the impression when it is seen with the eyes of someone who is looking at this image in the 1950s when it was made.

However, transport that image now, to the year 2005, and it takes on a completely different meaning. It can still be interpreted as a fairy-like setting. But it's also easy to interpret it in a completely different way in this age when we're so worried about violence against children and all of these current social issues and social

ills. It is necessary to understand this image *in its time,* or it gets completely misunderstood in our time.

Maybe we photographers need to think about this and know that our images are going to have to be explained 50, or 100, or 500 years from now, just like Shakespeare or Renaissance paintings need to be explained to us today.

The Sketch Exercise

Most of us probably left homework and exercise drills behind us when we left school. But a few of these exercises are absolutely marvelous in what they teach us about photography and the creative process. Here's one.

Take out a piece of paper and—I mean this literally—do this exercise. You'll be fascinated by it. Bring forth in your mind's eye a photograph you've made. Choose one of your best, one of the ones where you really think you nailed it. Now, draw on your paper **without looking at the photograph**—strictly do this from memory—draw the basic shapes, the basic lines, and the basic forms of your image. Just make a quick sketch. Don't include any fine details or shading—just the basic shapes and the basic forms.

Now, go get the photograph and compare it to the sketch you made. You'll be absolutely amazed how different the sketch is from the photograph. There will be things in the photograph that you completely forgot to put in the sketch. The will be things in the *sketch* that are absolutely not in the photograph! Obviously, such things exist in your mind's eye only. It's a fascinating exercise.

Do this with a bunch of your images and you'll learn a great deal about how the mind plays games with the images that you think you remember or that you think you've made. It's also equally interesting to do this exercise with some great images in your

mind's eye from other people—from the masters of photography or painting. Do the sketch, pull out the book, and see how they differ. It's a great exercise.

I owe this one, by the way, to Ray McSavaney, who taught this to me in workshop back in the early 1980s. He's a marvelous teacher, and this was one of the best things I learned from him.

More Than a Mere Record

The general consensus is that a photograph is an intersection of a place and a time. That's a very seductive idea, and it is *technically* true.

But I've always felt that to make a *fine art photograph*, to make one that's meaningful in the artistic sense of the word, goes way beyond this simple intersection of place and time. A fine art photograph, in my opinion, is an intersection between an *image* and an *idea*.

I can illustrate this point simply by considering a great photographer like Ansel Adams. He photographed rocks and trees in Yosemite. Well, *lots* of people photograph rocks and trees in Yosemite. And in that place at any given time, just about anybody can make a picture of the rocks and trees at Yosemite. But what makes *his* images of Yosemite so fantastic is the intersection of an idea and an image. In his case, the idea has to do with the preservation of the earth with the sanctity of the natural world. His whole relationship with the natural environment, the Sierra Club, and his entire life are a part of what makes Ansel Adams' images something more than mere snapshots. My contention is that all the great fine art photographs in the world share this common theme of being an intersection between an image and an idea.

What I propose, as a way to prove this, is for you to go over to

your bookshelf, pull down all the great photographic books you have, and start looking at them. Ask the simple question, "What is the idea behind this photograph?" By that I mean the idea in a bigger sense than what we see in the photograph itself. What's the idea that informs the image? What idea makes the image meaningful and not just a mere record of what happened to be in front of the photographer at the time they happened to click the shutter? *Ideas* are the source of great photographs, not merely time and place.

Looking Deeply

When I was in high school, my science teacher had us involved in a very interesting experiment. It was simply this: Write down as many observations as you possibly can about a pencil. I bet some of you are familiar with this exercise because you probably went through it, too, if you took a high school chemistry class.

The challenge was to see how many different kinds of observations you could make about something as innocuous as a pencil. What it taught me was how, when we look at something intently, with focus, when we look deeply and allow ourselves to see more than we see at first glance, how *much* there is to see, how rich the world is.

My proposal is that if this is true for something as innocuous as a pencil, how much *more* true could it be for a piece of artwork?

My friend Morrie Camhi once did an interesting experiment. He posted a group of his photography students outside an art gallery and they timed how long people spent in the gallery by noting when they went into the gallery and when they came out. They did this with a number of people and then statistically divided the time they were in the gallery by the number of pieces of artwork

that were on display there. From this they determined the time spent *per piece of artwork*. It was amazingly short—a matter of mere seconds. How can you possibly understand a piece of artwork in a matter of seconds?

What I'm proposing is that as photographers, just as we've had to learn how to look at the world more carefully, we should also look at photographs and other works of art more carefully. So try this: look at a book and do what Minor White used to suggest: Spend 30 minutes looking at a single photograph. Thirty minutes! See what there is to see. Observe how you react to it. Note how your reactions evolve over time.

It's a fascinating experiment, and one I recommend to anybody.

Seeing Art Through the Seasons

If you ask people why they want to own art, probably the most prevalent reason is *because of the investment value.* Somehow we're going to buy art as though it's stocks and bonds. We're going to save it for a while, it's going to appreciate in value, we're going sell it, we're going to make a killing.

Yeah, right.

I suppose there's nothing wrong with this, in theory. If you do want to sell a piece of artwork, it'd be nice to make a little money on it. I can understand that. But I propose that the vast majority of people who are buying artwork are involved in art not for investment, but because they love the art!

A friend of mine once said, "I don't care whether or not my art is going to appreciate because I don't have any intention of ever selling it. I purchased it because I want to *own* it. I want it to become a part of my life." I think this is probably true for most of us.

One of the real advantages to owning artwork is how your relationship to the artwork changes over time. I've noticed this, for example, when I have photographs hanging on the wall for a while. When the light changes on them during the day they look different, they feel different, I respond to them differently. As my *mood* changes over the course of a day, or a week, or a month, my response changes. And most fascinating of all, as the seasons change during the course of the year, my response to the artwork changes, because I see it in a different context. I love this aspect of living with artwork for a long period of time, because it changes *me* as well as changing my relationship to the artwork.

Photography in the Age of the Quick Cut

Yesterday I was talking about how long we look at a photograph and how much of our time and attention a photograph deserves. I want to share another thought about this idea. It's simply this: we live in the age of the quick cut. Just look at a commercial on television, look at a music video, or even look at a television show. Pay attention to the number of quick cuts there are between one visual image and the next. This is particularly noticeable in 30-second commercials.

Worse, it used to be that it was *only* in commercials or music videos that we saw this quick cut technique that has become so fashionable today. More and more I'm starting to see it in *everything*: watch one of the cable news broadcasts—Fox News, CNN, or MSNBC—and pay attention to how many graphics there are on the screen while you're being fed the news by the reporter. There is so much going on! We are supposed to be multi-tasking and quickly getting information. Boom! an image comes on, then goes off, and we're supposed to absorb it in a blink. We're being trained,

visually, to see images that way. We're being trained that if you can't get the content of an image instantaneously, than somehow it's an inefficient presentation of information.

As a photographer, I resist this. I don't like the idea that I'm supposed to be able to get everything an image has to offer the instant I see it. This implies that I can see and comprehend an image instantaneously *because it's so familiar to me*. It means I essentially know what I'm seeing the instant I see it. This is the opposite of what photographic art is supposed to do—which is to teach us to see things that we are *not* trained to see without the help of the photographic artist.

What's Left Behind

After my Mom's funeral last week, I spent several days with the rest of the family sorting through her personal possessions and cleaning out her residence. Strange as it may seem, I had a very interesting observation about what she left behind. It got me thinking about photography and our lives as artists.

She left behind three kinds of things that were worth keeping. Most of it was just *stuff* that we could easily throw away, which had no importance and no value to anybody anywhere. But there were three categories of things that I noticed we all thought were important and valuable. The first were the family photographs, the memories, the visual history of our family. That was so important for us to keep. And then there were the pieces of artwork that she made herself, things that she created with her own hands, with her own creativity. Some of them were, honestly, not very good—but it didn't make any difference. The fact that she made them with her own hands made them valuable to all of us. And then there were the things that she had purchased, or were given to her, that

were just extremely well done, things that had quality in and of themselves, things that you could admire for the sheer magic of the object that they were. When it was all said and done, we kept the photographs, we kept the things she made, and we kept the things that she owned that were really special because they were of an extraordinary quality. That was it.

Somehow, as I was thinking about all this on the long drive home, it made me think that there is something to be learned here for those of us who are photographers. Important photographs, things we make with our own hands, and things that we make extremely well—to the very best of our abilities—these are the things that will be our artistic legacy. The rest of it is just *stuff*.

Success Happens When Opportunity Meets Preparation

It goes without saying that bumper sticker wisdom isn't always true, even though it's often clever. But here's one that *is* true. I learned it years ago and I do my best to live by it, even though I don't always meet up to it. This is one of those little motivational phrases that has stuck with me over the years: *Success Happens When Opportunity Meets Preparation.* I think—I'm not positive about this—but I *think* the origin of this phrase was great football coach Vince Lombardi.

Here's a good example of why I think this wisdom is true. On occasion, as a publisher, we find ourselves with some plan that falls apart when we are preparing to publish the next issue of the magazine. We think we have a portfolio lined up, but the photographer can't provide us with the prints. When that happens we have to make a few calls to people we weren't intending to publish so quickly and spring on them, all of a sudden, "Gee whiz, there's an

opening and we've gotta fill the hole!" You'd be amazed how many times the photographer says, "I don't have the prints ready, and I can't send them to you." What a disappointment that is—for both of us! The success fails to happen because when the opportunity arrived, they were not prepared.

Every once in a while, an occasion will arise where we'll call someone and say, "We've got a slot in the magazine. Can you send us some prints?" and the photographer says, "Yes! I'll have them FedExed to you this afternoon and you'll have them tomorrow." I cannot tell you what a joy it is to work with professionals that are *prepared* to be published. They have their bios ready to go, they have their prints ready to go, they have their artist's statement ready to go, and they are *professional* in the sense that they can respond to an immediate demand.

What I'd like to suggest is this: this is not a bad strategy. You never know when someone is going to come knocking at the door and present to you a photographic opportunity that can only be capitalized upon when you're prepared.

What You See Is What I Took

This coming weekend is the big art festival weekend here in Anacortes, Washington, where I live—it literally takes over the town. Artists come in from all over the country. They shut down Main Street. It's a big street fair with booths and arts and crafts of every kind, a big show down on the dock. It's a giant event. It's probably *the* marquee event in my little town up here in the north-west corner of Washington.

Last year I saw something that absolutely fascinated me. You have to visualize, there are more than a thousand creative artists here, all trying to do interesting artwork that people will want to

buy. Some of it is relatively simple, some of it is complex. Some of it, like in all street fairs, is a little shaky. A lot of it is very, very good. The art that's represented here varies greatly in terms of quality, design, and type, but one of the key elements that is consistent is the creativity that these people try to bring to their artwork in order to do something unique and different. Keep in mind, all these street vendors are competing with one another to make something new and different so that they can sell their work in the street fair.

In the middle of this event, with literally hundreds of booths, there are a few photography booths. One of them really caught my eye, because this fellow had a sign up in his booth that said, and I quote, "What you see is what I took. No computer, no digital, no manipulation." And I was absolutely fascinated by that, that in the first place he felt he needed to say that, but in the second place it dawned on me that here in the midst of this art festival, where every single artist is trying to bring forth the creative muse and be as creative and innovative as can be done in the art fair, here we have a guy saying, in his photography booth, "I used absolutely *no* imagination, *no* creativity, *no* anything to make my artwork. Instead, all I did—what you see is what I took—all I did is record what was right in front of me."

I thought, "Isn't that odd that in the world of photography there are people who think that mere recording of what is in front of them is art?" And in my opinion, they completely miss the point of what the creative life is all about.

Toys or Tools

One of the consistent themes in my recent conversations with

photographers about their equipment choices is the challenge they're facing taking digital photography seriously.

Because of my personal history in photography, a lot of my friends are large-format photographers. They're shooting 4x5's and 8x10 cameras—these are cameras that are pretty easy to take seriously. They're expensive, there are a lot of gadgets that have to be employed in order to use them successfully, and it's expensive to shoot sheet film. As a result, when these people pick up a digital camera, it just feels like a *toy* to them. Everything is automatic—focus is automatic, exposure is automatic, bracketing is automatic. There is no film cost; they don't have to develop the film when they get home. It just doesn't feel like a *serious* tool. Yet people who are using these tools in a serious *way* are realizing that they can do some very nice photographs and some really interesting artwork with them.

This leads me to think that when it comes to tools, it's not the nature of the *tool* that determines whether or not it's a serious tool, it's the nature of the photographer's *mind*.

If we approach the use of a tool in a serious way, if we approach it with a certain amount of creativity, reverence, and respect for what it can do, then it can be a serious tool. But if you insist that a toy is *merely* a toy and you don't approach it carefully, and thoughtfully, and deliberately, then a toy will *be* a toy and the results will be likewise.

Confessing a Constructed Composite

I had a conversation recently with a woman who has a new book coming out, and we were discussing one particular image that, as it turns out, is a *composite* image. It is a very large landscape that she photographed in sections and then digitally stitched together to

make one giant composite image. It looks like it's a straight image out of a straight camera, but it isn't. It's a constructed composite image, and she felt compelled in the book to confess to her readers that this is, indeed, a constructed composite image made from several negatives.

For the life of me, I didn't understand why it was so important to confess this. What difference does it make that the image was constructed out of several images stitched together, as compared to having been taken with a larger-format camera with a really wide-angle lens, or some such thing? We don't feel compelled to confess to our readers that we used, for example, a telephoto lens, which brings the object much closer to us than the human eye would normally see, or a wide-angle lens, which presents a much broader point of view than the human eye would normally see. We don't confess that we've dodged, or burned, or flashed, or bleached to change the tonal representation of our black-and-white photographs in ways that make the image more what we would like it to be rather than what the actual film recorded. We don't confess these things. Why do we need to confess that something is a *construction?* What we're interested in is preserving the element of truthfulness, and if we have faithfully and truthfully represented what's in front of us, why is it necessary to admit the construction?

I guess confession is good for the soul, and some people feel the need to be specific about how they made an image. For me, it boils down to, where do you feel it is necessary to draw the line? And I think this is a silly place to draw the line—that we have to *confess* when we've constructed an image.

The Fantasy Market for Photographs

I often find myself talking with photographers about the price

of their work. One of the more interesting observations I've made over the years is how few photographers have ever paid as much for a photograph as they offer their photographs for sale for in the gallery. I'll often find photographers who are represented by galleries and price their work at $800, $1,200, $2,000, or even $4,000. I'll often find that these photographers have *never* paid that much for a photograph themselves.

So, somehow they think there's a bunch of people out there who just have *so* much money that they can afford to just give it away, that they make decisions about purchasing artwork in a completely different way than the average human being, because to them money is just so easy: "We'll just flush it out there in the world and give it to deserving artists, because what the heck, money comes so easily to us."

Well, you know what? I don't think those people exist. I don't think there are people out there in the world for whom money comes so easily that they just throw it away on expensive, overpriced artwork. I just don't think people do that. Matter of fact, I think the people who really *have* lots of money have money because they understand the value of things.

So, one of the things that you might think about when it comes to how much you think your photographs are worth is how much you are willing to *pay* for photographs, because you and the people in your income bracket are the art market just as much as those people who you think are out there and have unlimited amounts of cash to spend on artwork. The lottery mentality—that if we can just find that group of people out there who are incredibly wealthy—is the best way to *not* sell artwork, because if you're waiting for *those* people to fund your creative life, you may find it's a tough and long wait.

Limbering Up

If the process of being an artist is both learning about ourselves and about our artmaking, then one of the things that I've learned about my process is that I can't just go out and make brilliant images from a dead stop. I'm more like an athlete—or maybe even a car.

You don't race a car from dead-stop cold. You have to warm it up. An athlete has to stretch, they have to be prepared, they have to go through a certain routine in order to perform at their highest level. Well, I'm sort of the same way photographically. I can't spend six weeks without doing *any* photography, and then go out on the weekend and be brilliant and see great photographs instantaneously from a dead stop.

I've learned that it's better for me if I'm constantly working a little bit, every day. If that means that I'm going to go out on a weekend and make photographs and try to do interesting work, then I need to get the camera out on Monday, Tuesday, Wednesday, Thursday, and Friday night—even if I only do it for an hour or two—just to get myself limbered up and loose so that I'm ready for the weekend.

In other words, in order to be creatively limber, I have to go through the process of limbering up. I've learned to pay attention to this, even when I don't have the opportunity to limber up during the week. If I'm just going to go out on Saturday morning and do some photography, for example, and I haven't had the camera out for a couple of weeks, the first thing I do is allocate about 30 minutes, or an hour, or two hours to just making some pictures that I know are probably not going to be very interesting, but they limber me up, they loosen me up. I have to break the camera out, and I think knowing this about myself makes the time that I *do* have to photograph more productive.

Multiple Palettes

For 30 years now, I've considered myself a black-and-white photographer. Some of my friends are color photographers. Few of them are both, and I've never known anybody to do both black-and-white and color photography in the same image. But that's one of the things I'm starting to see, and I have to admit I'm fascinated by it. I'm not sure it isn't just a gimmick, but one of the things that can be done now with all of this computerized digital stuff is the blending of color and black-and-white photography in the same image.

It's even more subtle than that, though. You can make sections of an image black and white, sections of an image color, sections of an image sort of in between—sort of a pastel, faded-out color. You can do all of these things in the same picture.

This is one of those little techniques that might end up being very trite when we look back on it in five or ten years—or it might be very creative, I'm not sure yet. I'm not convinced I've seen anything that's really terrific, but I know this: it's one of those doors that's opened up, one of those possibilities that has presented itself to us with all of these new technologies.

I'd sure love to see if anybody out there is doing work this way that is really captivating. It's such a new way to think. I'd be fascinated to see the creative process that you're going through if you're making images that have a variety of palettes.

Blind Zip Code Junk Mail and Art Books

Long before I started *LensWork*, I had a career as a marketing consultant. One of the old rules of thumb that we marketing consultants used is that if you're doing a direct-mail campaign (send-

ing out junk mail), you can pretty much expect somewhere be-
tween a tenth of a percent and a quarter of a percent of the people
to respond if you just send it blindly to a ZIP code.

I want to compare that to the market for photography art books.
In talking with hundreds of photographers about the books they've
published, I've found that the average photographer will only print
a couple thousand books. A press run of five thousand is *huge*. I on-
ly know of a few press runs that were more than that in 30 years
of photography. So if you can sell—at most—a couple thousand
photography art books, that's .0007 percent of the population of
the United States.

Doesn't this tell us something about the market for fine-
art photography books, about the price for fine-art photography
books, about what people think about fine-art photography books?
It bothers me a little bit that I could take some stupid product and
sell it way more successfully in a blind marketing campaign to ZIP
code advertising via junk mail than I can by producing a finely
crafted, superbly printed, fine-art photography book. Something
is just plain goofy with all of this. I can't quite put my finger on it,
but it bothers me.

Frederick Evans and the Fleur-de-lis

Some of the most stunning photographs I've ever seen were
from the photographer Frederick Evans, who photographed in the
early 1900s. He did some absolutely marvelous work in the English
cathedrals. His *Sea of Steps* is one of my favorite photographs of all
time, and I had a chance a number of years ago to see a group of
his original work that's held in the collection of the Art Institute
of Chicago.

I had called and made an arrangement to visit there and see

these photographs, and I was *absolutely stunned* by their sheer beauty. The image quality was fantastic. But of equal curiosity to note was the way they were presented. They were all glued to rather cheesy kinds of illustration board and cardboard. And someone— I don't know if it was Frederick Evans himself, or some assistant, or if he hired out to have this done—but *someone* had taken pen and ink and drawn around the photographs, on the mat board, the most incredibly ornate fleur-de-lis, and lines, and curlicues, and dots. They had tried to sort of *jazz up* the mat board by drawing this pen-and-ink border around these absolutely gorgeous photographs.

Well, the combination of the two made for the most curious presentation, because here's a gorgeous photograph on the cheesiest mat board you've ever seen. And it got me thinking about how we can really ruin our work, if we're not careful, by bad presentation, by badly cut mats, by the wrong colored mats, by... oh, there's probably a thousand ways.

These things, I'm sure, change with time. Maybe in his day the fleur-de-lis and the pen-and-ink drawn borders around the photographs were all the rage, and these were supposedly really fantastic. I don't know. Maybe some photo historian can let me know. But by looking at those photographs by today's standards, it really did make them look pretty cheesy, because it just wasn't a very flattering presentation for an absolutely wonderful photograph.

Creativity on Demand

We all operate under a few basic assumptions, and in my case one of the assumptions is that there is such a thing as the creative muse. That is to say, I can't be creative, necessarily, on demand.

Now, I don't believe in the muse as some kind of angel floating

around that bonks me on the head with a creativity wand. I do believe, however, that the mind is constantly working on solving creative problems and seeing creative ideas, but it does so often on a very subconscious—even unconscious—level, and that sometimes ideas and solutions just bubble up from the well of our own subconscious mind. Sometimes we connect dots in our brain that we can't connect in our mind, and not until that comes forth in our mind do we see it.

So I have great faith in brain, even more than I have great faith in mind. That's what I mean by the creative muse. Well, you can't—at least I can't—call this forth on demand. Sometimes creative ideas strike me at the oddest times, when I'm totally engaged in something not photographic. When I'm in the shower, when I'm out to dinner in a restaurant with some friends, all of a sudden, boom! There's some creative idea. So I've learned to do a couple of things.

The first is, I've learned to capture these ideas when they come to me by constantly carrying with me a little pocket recorder, so that I can make a quick note and recall things later. The second thing I've discovered, photographically anyway, is that I can increase my odds of the creative muse being involved in my photography when I spend more time *doing* photography. It's as simple as that. The more time I spend making pictures, the more time I spend printing pictures, the more time I spend working with pictures, the greater the chances are that I'll be with the camera or in the darkroom when the creative muse strikes. Then the challenge is to simply be receptive to it.

Cartier-Bresson and The Decisive Moment

When Cartier-Bresson passed away, I read a lot of the biog-

raphies about him in the newspapers and on the Internet. Every single one of them, without exception, included as one of the primary comments about his life the phrase "the decisive moment." Cartier-Bresson is known for this phrase. It was the title of one of his early books. I got absolutely sick about reading "the decisive moment" over and over and over again, as though somehow this explained Cartier-Bresson. It's too easy to take such a phrase and use it as a means to pigeonhole a creative person's life.

There's no question that the concept of "the decisive moment" was important to Cartier-Bresson, but it certainly wasn't his entire existence or his entire creative and photographic life, and I'll bet he got sick of the phrase. He was too passionate an individual, too interesting a philosopher of life, a commentator on life, to simply say that he was a master at capturing "the decisive moment." He *was*, of course, but that wasn't *all* that he was.

Somehow that phrase becomes available to shallow historians, and shallow newspaper reporters, and shallow obituary writers as the sum of his entire life. His was the life of the decisive moment. No, it wasn't. That was one thing that he did, and he did it exceedingly well. But to pigeonhole a guy's entire creative life into one phrase is to essentially be able to dismiss his entire life by wrapping it in that little box and saying that's who he was. I find that a bit bothersome. It's too easy to simply say, "Cartier-Bresson, the decisive moment," as though somehow, having said that, you've said all there is to say about such a marvelous man and a marvelous photographer who changed the way we see the world.

Archival Processing

I'd like to share a few thoughts about archival processing, which is such a big to-do in the world of fine-art photography. The very

best estimates seem to indicate that a photograph's only going to last two or three hundred years at most. How long have the Renaissance paintings lasted? What about the statues of Michelangelo, or even the Greeks? They've been around forever.

We photographers like to think that our work is going to last for a long time, but it's time to be realistic. If you really want to make archival artwork, don't make a photograph, because, first and foremost, anything made on paper is fragile. And certainly photographs are fragile, not only because of the base of the materials, but because the chemistry itself is fragile.

Even more fundamentally than that, I have to ask, what's so important for photographers about trying to make their work archival? Why is this a big deal?

I suspect some of it is no more complicated than vanity, that somehow we would like to think as artists that what we're doing is important, that it matters, and that it's important for it to be around so that future generations can learn from our wisdom and vision, et cetera.

Of course, there's the market, too, and we'd like our work to be represented as being archival so that investors don't have fears that buying a photograph of ours is going to be a bad investment because it's going to deteriorate or something. But for me, if my work lasts 20 or 30 years, that's all I really care about because that's as long as I'm likely to be around the planet and then some. And I don't know that anything beyond 20 or 30 years is important.

This is not to say that I want to use sloppy techniques and bad chemistry that I know is not archival. But I'm not going to be too hung up on it, because quite honestly, if my photographs last 50 or 100 years, that's just great. What's more important to me is that the photographs that I produce and distribute *now* make an impact *now*. I'm not willing to put much faith in the idea that the photographs I make today will be somehow valuable in the future. I'd rather make them valuable today.

Being Quiet

I've come to the conclusion that the technology that I've grown accustomed to and that I live with every day is getting in the way of my photography.

I'm not talking about camera technology; I'm talking about some of the other technologies. We live in the age of the Internet, the computer, the television, the radio, the CD player. There's so much noise that comes at us on a regular basis: the traffic, the hustle and bustle of life.

I don't think that I take enough time to stop and really listen, and look, and observe, which is the great task of a photographer. It's not making pictures. It's watching; it's observing; it's *seeing* life. I don't spend enough time listening. I think this is why so many of my friends who are landscape photographers love to get out and photograph. They love to be in the land, in the quiet, in the desert, in the forest, where they can hear not technology, but nature. Here's an example of how things have changed for me of late.

When I used to go out photographing, I would drive around with the music on, or with a spoken-word tape playing in the car, maybe even with the radio on, and I would be involved in the technology while I was out looking for photographs. Now I turn all that stuff off. I've discovered that it diverts me from the attention of seeing, that multitasking may be a virtue in today's hectic life, but it's not a virtue in art making. I turn off the air conditioner. I roll down the windows. I let myself get hot and sweaty, and deal with the flies and the mosquitoes, because that puts me into the place I'm trying to photograph better. I've discovered that the more I turn off, the more I can plug into what's happening in the world. And I think my photographs have gotten a lot better because of it.

Bullet Composition

One of the most devastating critiques I ever had about my photographs was from a guy who said simply, "Why do you put everything in the dead center of your photographs?" He was right. All I had to do was engage a little exercise to look at my photographs—draw an X from corner to corner—to see that all of my subjects were dead center.

I realized the camera was sort of guiding me in that direction. After all, the viewfinder has a little X or a little square right in the center, and I tend to want to focus on what it is I'm focusing on. But that doesn't necessarily make good pictures.

In the world of painting, this is called "bullet composition," bulleted dead-center in the middle of the target, and it is generally considered the most boring composition there is. We see countless submissions to *LensWork* where picture after picture has the subject matter dead center, and almost nothing surrounding it that's of any interest whatsoever. The static nature of these compositions is literally mind-numbing.

Of course, the old remedy to bullet composition is called the rule of thirds, and it can be kind of trite in some aspects. But if you're going to err with a trite composition, you're much better off to err with a simple rule-of-thirds composition than to err with a bullet composition almost every time.

As a fascinating exercise, pull down some books of your favorite photographers—the best photographers there are in the world. You'll be amazed. There's almost never anything dead center in the photograph. There are some exceptions—people like Diane Arbus come to mind—but even her work a lot of times is slightly off-center. When people who are new to photography ask me what's the most important thing they can do to improve their pictures, almost without exception I tell them to stop putting the subject in the middle of the photograph.

Living With It

When making a photograph, one of the most productive things you can do is print it in the darkroom as well as you possibly can and then take that print and tack it up on your bulletin board, or tape it to the mirror in the bathroom, or above your dresser, or on the refrigerator—someplace where you can see it and live with it for a few weeks.

It's absolutely amazing how your thinking about this image will change as you view it over time. Then, after you've lived with it for a while, go in the darkroom and make the final print. Every time I do this, I'm amazed at how much I learn about the image by simply living with it for a while. I see differently, I think differently, and I end up creating differently.

I would like to think that I have the photographic equivalent of the genius of Mozart, essentially working as though I'm taking dictation from God, but I know that most photographers don't work this way. We don't possess that genius; we're not that inventive; we're not spontaneous enough to be brilliant instantaneously. What really happens, at least for me, is that my thinking evolves and deepens with time.

Painters, of course, do this all the time. It takes days, weeks—months, sometimes—for a painter to complete a painting. Of course, they can work quickly too, but more typically a painter working in oils has time to work with an image, time to evolve, time to think, time to work out problems, so that the painting is the result of a process that they've worked on over time. The inspiration might be instantaneous, but the final result is not.

In photography, the inspiration might be instantaneous; the photograph itself might be a sixtieth of a second; but the final printing, the final cropping, the final presentation might be the result of days or weeks of thinking about and working with a photograph.

Sometimes I get lucky. Sometimes I live with it for a couple of weeks and I decide that the very first print was absolutely spectacular. I can't make any improvements whatsoever. Hey, there's nothing wrong with that. Take all the easy ones that come your way. But more often than not, I find it works better as a strategy, as a regular part of my creative process, to live with prints for a while before I make any final decisions about how I'm going to make the print. There is no doubt in my mind that living with a photograph for a while before you make the final print will always change the image, most often for the better.

Playing Around

I'm very definitely an advocate for just playing around photographically. I think sometimes we get too serious about our photographs, particularly if you're trying to make serious fine-art photographs. It's far too easy to get caught up in the seriousness of what we're doing, because after all, we are trying to do serious artwork.

The counterbalance to that is to allow yourself just to play around sometimes. Just shoot photographs for no other reason than to see what happens, to fool around, to try ideas that you would never, ever try if you were serious about them, just to see where they go, to doodle photographically. I think this is a great way to limber up and loosen up the creative juices, and I've found more often than not when I do so, I create uninteresting artwork, but I do open up very interesting doors. I see things in ways that I haven't seen them before. I see new ways to approach a photograph that I haven't used before.

It's the *process* of playing around that's interesting, not the *result* of playing around, and so one of the things I've learned about playing around is to pay attention to all the times I reflexively say "no"

to myself: "Oh no, you can't do that. Oh no, you can't photograph that. Oh no, that won't work. Oh no, I've tried that before."

Wherever I tend to say "no" to myself when I'm playing around are the places I need to pay attention, because those are the places that indicate where I've tried and failed—not because it can't possibly work, but because the way I used to do things or the way I did it at that time was not possible to be successful with, or maybe even was just inconsistent with what I was trying to accomplish at that time. But now, with a new product, a new idea, a new photographic objective, revisiting some of that old stuff that didn't work before might work great now.

Making a Commitment and the Conflict that is Inevitable

So much of modern life is caught up in conflict. Whether it's political conflict or legal conflict, it's all over the news; it's all over TV; it's all over our lives; it's all over our office politics, so that an awful lot of us just get to the point where we've had enough conflict.

This is a topic that's worth considering relative to the making of artwork, because there's nothing more difficult in making artwork than making a commitment, for the simple reason that the minute you make a commitment, and a statement, and a piece of artwork, and you put it out there in the world for people to see, you are going to invite conflict. There are going to be people that don't like it; there are going to be people who disagree with you; there are going to be friends that tell you that it's a great piece of work, but if they did it they would have done it *this* way.

So, in some regards it's a lot easier to avoid the conflict and the differences of opinion by simply not making the artwork, or not

showing the artwork, or not saying, "This is what I believe. This is what I stand for. This is the artistic statement that I choose to make." That's a tough thing to do.

This may be the source of so much banal artwork—the kind of artwork that runs no risk whatsoever of offending anybody or conflicting with anybody. Now, don't get me wrong. I'm not advocating conflict as a means of creating great artwork, because just *because* it's controversial, or just *because* there's conflict involved, doesn't say anything about whether or not it's interesting or good artwork. That's another whole topic entirely.

I propose that if your objective in making artwork is to avoid conflict, or if your fear in making artwork is that people won't like it or it will be controversial or it will put you into a position of conflict, the only practical outcome of that avoidance of conflict is the procrastination to do work. You just won't do it, and that's a shame. For all intents and purposes, being an artist is putting yourself in the middle of controversy, in the middle of conflict, and taking a stand that puts you in a position where people will disagree with what you've done. It comes with the territory. It's part of being an artist.

The Golden Mean

No discussion of the aspect ratio of artwork is going to be complete without at least mentioning something called "the Golden Mean." If you're familiar with this, you know how fascinating it is, and if you're not familiar with it, you should be, because it's a very interesting idea.

The Greeks discovered that there was a particular ratio of height to width that they claim was most aesthetically pleasing, and they called it the Golden Mean. It's the ratio of 1.618, roughly

speaking, to 1. This would make an image that's 8x13; think of it roughly that size. What's so magical about this particular ratio is that it has some very unusual mathematical properties, which the Greeks claimed were divinely inspired and therefore the best ratio for creating artwork.

This particular rectangle is the basic shape of all Greek architecture. If you look at the ruins in Greece you'll find the Golden Mean and what's called the Golden Rectangle repeated over and over and over again.

The Golden Mean was studied at length by an Italian mathematician named Fibonacci, who discovered an interesting ratio of numbers called the Fibonacci sequence. If you want to take a look at that, you'll probably find lots of information on the Web.

One of the things that fascinates me most about the Golden Mean and the Golden Rectangle is that if you take a Golden Rectangle—any rectangle that has the ratio of 1.618 on the long side to 1 on the short side—and you cut off a square, the shape that's left is also a Golden Rectangle. And if you cut off a square from that, the shape that's left is a Golden Rectangle, and if you do that repeatedly, eventually what you end up with is sort of a spiral of rectangles. If you then draw a line that connects the center of all those squares in a nice, smooth arc, you end up with a perfect logarithmic spiral.

There is some magic about the Golden Mean. It's worthy of a long study if you're fascinated with such things, as I am. But as a photographer, one of the things that I've discovered is that it is fascinating to make pictures in this ratio, or at least attempt to. If you want to prove this for yourself, just try it. It's a fascinating exercise, and I must admit there is something absolutely lovely about this particular ratio.

Who knows, maybe the Greeks were right—maybe it is divinely inspired.

The Sequence of Things

I had a fascinating conversation with a friend of mine who had produced an interesting little project and shared it with me. We noticed a fascinating thing that I hadn't paid attention to before, and I can best explain it this way.

When Edward Weston made photographs in the 1930s and 1940s, he started by simply making photographs. Someone saw these great photographs and decided to give him an exhibition. Then he got popular enough and he was successful, so a book of the work was published. And so the sequence for Edward Weston was from original photograph, to distribution to a small audience, to distribution to a large audience.

What was so fascinating about the conversation with my friend was how the sequence today was, at least for him, exactly backwards. He started by photographing a series of still lifes with his digital camera. He duplicated and shared them via e-mail and via a Web site with his small circle of friends. But a bunch of us who saw them thought, "This is really great, and maybe you ought to take this work and actually produce fine-art photographs from it."

Do you see how that's backwards? He started with a project, which ended up being distributed in essentially an electronic exhibition of some kind or another, and we all said, "Well, what the heck? Why not make some original prints as the final and last step?" If we had said, alternatively, "Gee, that work's not very interesting," he probably would have never made original prints.

As it was, he was motivated to take it to the final step of making photographs, having started with the preliminary step of distribution. What a strange world we live in, where such a fundamental concept of photography can be turned absolutely backwards and make more sense today in perfect reverse than it did in Edward Weston's day, just a scant 60 or 70 years ago.

The Universal Icon for Photography

You know those universal tourist symbols that they have for indicating where the restroom is, or those kinds of things? They always come up with little pictures. Well, what do you suppose we should use as the icon for a photographer? You can't use a camera, because cameras look different from generation to generation. So what is the universal icon for a photographer?

You may think this is really silly, but these are the kind of questions that fascinate me. When I've got nothing to do, I sit around and think of these things, and I've decided that the best universal icon for a photographer is the tripod. It's the one piece of equipment that is essentially the same today as it was 150 years ago when photography started. It's the one piece of equipment that photographers use that almost no one else does.

Isn't it interesting that the tripod is also an indication of seriousness in photography? Years ago, a friend of mine was traveling through the redwoods in California and he got stopped by a park ranger, who asked to see his photography permit. My friend was nonplussed. He said, "What do you mean, a photography permit? I'm just taking a picture of the trees." And the ranger said, "Oh, no. You've got to have a photography permit to photograph in the redwood forest." Well, he'd never heard of anything like this, so my friend asked, "Okay, what do I have to do to go get a photography permit?" and the guy said he had to go back to the rangers' station, which was 50 miles in the wrong direction, and he had to fill out a form, and he had to pay a fee. My friend thought this was nuts. So he asked him, "Why do I need of photography permit? When did this come about?"

Well, it came about, evidently, because there were filmmakers from Hollywood who were using the national forests to make money. They would film their movies there, and the Forest Service had decided that they didn't want that to happen without having

some sort of control in licensing and permits, et cetera. So they instituted this policy that if you were going to make professional images in the National Forest you had to have a permit.

Well, my friend thought this was nuts, and he said, "How do you know I'm a professional? What is the criteria that you're using to determine that I'm a pro instead of just an amateur?" And the ranger said, "Because you're using a tripod." And that was the definition of a professional photographer, according to the Forest Service.

Eventually they got enough grief for this stupid policy that they rescinded it, but the story to me was the idea that the tripod is the piece of equipment that differentiates you as a professional photographer. And if you don't think is the case, go out somewhere with your tripod and set up and make a picture, and watch how much respect you get from the people who are surrounding you, who maybe only have a 35mm strapped around their neck. With a tripod—ooowhee!—you're an important person.

Ways of Learning

Because I'm the editor of *LensWork*, on a fairly regular basis I'm approached by someone who's starting off their photographic career and they ask me for advice on how they might engage something that will improve their photography. What's the most important thing I recommend they do?

I've had to think about this seriously, because they're asking a serious question and I don't want to give them some trivial and unimportant answer. So here's the answer I give all of these people, and it's an answer that I wish someone had given to me, because I had to learn it by the school of hard knocks. And it's simply this: different people have different ways of learning.

For some people, the best thing to do is go read the instruction manual to their camera, or some how-to book. For other people, the best way to learn is to go take a class. But my way was different. I almost never learn something by setting out to learn it. I tend to learn things by throwing myself into a project and learning because I need to—necessity being the mother of invention, as it were.

So the most valuable thing I do to help my photography grow and to learn new things, is commit to a project that I have no idea how to complete. By putting myself in that position, it forces me to raise myself up by my own bootstraps and learn things that I wouldn't learn ordinarily. So I've learned to commit to a project—do a ten-print project or a six-print project. If I want to learn something about macro-photography, I commit to doing a macro-photography project. If I want to learn something about using studio lights, I commit to a body of work that uses studio lights.

This method may not work for everybody, but for me it's the best way to learn, and I've learned that I'm not the only one who learns best this way. So my advice is this: Figure out how you learn best, and then use that technique with repetition and consistency, and you'll find progress comes easily and steadily and surely.

Van Morrison and Paul Caponigro

One of my favorite musicians of all time is Van Morrison. I think he's just a genius and his work is spectacular. But at the same time I think he's made some of the worst music I've ever heard. It's fascinating—every single CD of his I've ever owned, there are always one or two songs that I think are just brilliant, and I want to listen to them over and over again and have them as a part of my long-term music library. But on the same CD he'll have a couple of clunkers that I just can't believe he put on the al-

bum. They are virtually impossible to listen to. I've had to learn to live with this because he's been one of my favorite musicians now for almost 30 years, and I've had exactly the same experience with every CD he puts out. So it's not an odd thing. It's just the way it is with Van Morrison.

And you know, I've learned this is actually a good thing. As an art consumer I've learned that it's good for me to be patient with artists and to give them a break, because they're creative individuals, and if you listen long enough, eventually you'll hear some really great stuff. But you have to give them license to experiment, and to play around, and to occasionally fail.

In photography I can think of no better example of this than Paul Caponigro. He's one of my favorite photographers. He's absolutely brilliant. But at the same time he's put out some work that I just scratch my head at. I just don't get it. His book *Megaliths* was one of the worst collections of photographs I've ever seen, particularly by a major and important, influential artist. But it's okay. I know lots of people who love that work. So it's not bad work; it's just work that never spoke to me personally. But some of his other work was absolutely wonderful.

As an artist I've learned from this too. I had to learn to give myself the ability to fall flat on my face, when work just doesn't work, because it's only in the midst of doing that that I can also occasionally create a photograph that really sings, that I really like, that has staying power. But I only get there by creating some really bad stuff along the way. The minute I start trying to avoid the bad stuff, I'm going to throw the baby out with the bath water, because the good stuff will stop being produced too.

Getting It Out of the Way

I was recently off photographing for a couple of weeks in North Dakota, and in one particular session I found myself attracted to what can only be described as a calendar photograph. It was beautiful fall leaves in a junkyard, with some metal parts in the background. I mean, it was truly a cliché photograph.

I knew there was going to be some good subject material in this particular place, but as I wandered around looking for photographs to make, my mind kept going back to the beautiful fall leaves. Now, I'm a black-and-white photographer, primarily. I rarely shoot anything in color, although I was shooting that particular day with a digital camera, so everything was being captured in color for later conversion to black-and-white. I knew this, and as a result I kept thinking about the yellow-gold leaves, and they kept plaguing my mind, and I found I couldn't let go of them—that is to say, until I decided just to shoot it and get it out of the way.

So I walked over. I composed a classic calendar photograph, beautiful color leaves, very cliché and trite subject arrangement, made the photograph, and was able to instantly forget about it, and move on, and see all the other photographs that I knew were going to be meaningful and important to me in the long run.

So, sometimes the best way to get rid of something that's plaguing your mind is just to photograph it so that you're then free to move on. At least, that's the lesson I learned in North Dakota.

The Taboo Against Printing Others' Negatives

A number of years ago I ran across a project idea that I thought was fascinating. A group of photographers had gotten together and decided to swap negatives in a round robin, so that each photogra-

pher made the best photograph they could from all the other pho-
tographers' negatives as well as their own. Then they'd get together
at the end and share the results.

I thought this was a fascinating idea, an interesting way to learn
not only about the process of printing but about the process of be-
ing creative with raw materials like negatives. So I proposed this
to a group of friends of mine, that we all make the best print we
could of our negative and then pass our negative off to, as it were,
the person to our left for them to make the best print they could
from our negatives, etc. And you know, I couldn't find anybody
who was willing to do it.

There is a sense of photographic blasphemy, I guess, that comes
with the idea of having someone else print our negatives. It's just
not done. And as much as I thought it was an interesting learning
curve and idea, it just somehow was crossing a line that people were
not comfortable with. They just didn't want other people print-
ing their negatives. I'm still not sure why people feel this way, but
it's a fascinating bit of human psychology. It's too easy to think
that people might be embarrassed that someone else could make
a better print from their negative. It's possible that's it, but I think
there's something deeper to this.

For example, a songwriter doesn't mind that someone else sings
their songs. As a matter of fact, they encourage it; they promote it;
they hope other people sing the songs that they've written. Well,
if the negative is the score and the print is the performance, why
did Ansel Adams lock his negatives up in the Center for Creative
Photography as a permanent archive that other people are not sup-
posed to print? Why did Brett Weston burn his negatives so that
no one else could ever print them? There's something very interest-
ing about this. It would take a psychologist, I think, to unthread
it all. But I still think it would be an interesting project and an
interesting learning curve to see how other people would treat the
raw material in my negatives differently than I do.

The Preciousness of It All

As a budding young photographer I was encouraged—that's not quite right—I was mandated to, I was dictated to, I was forced to think in terms of the preciousness of the photographs I was creating; that if I were a serious photographer I would create archival prints in pristine white mat boards underneath the hinged overmat. I was supposed to put a piece of vellum or archival tissue to protect the surface of the photograph, and use only the finest acid-free quality materials. There's just so much fussiness about all of this. It's just all so precious.

From time to time, we get a submission here at *LensWork* that takes this to the extreme. Photographers will actually send us portfolios for review that include all of the archival tissues, and even occasionally the white gloves so that we will only look at their photographs with the white gloves on. And I have to be honest. We just laugh, because as much as I hate to say it, we've discovered with absolute consistency that the people who are the most fussy about their prints are the ones who generally send us the worst portfolios.

Don't get me wrong here. I'm not saying that you shouldn't be careful. I'm not saying that you shouldn't use the best materials there are. I'm not saying that carelessness is a virtue. But my God, these are only photographs, and you can make additional copies, and they're just not that precious. Maybe a hundred years from now as collectible artifacts they might be, but there's a long stretch between a collectible archival photograph that needs to be handled with white gloves and care in a museum, and a submission to a magazine.

But there is that element that says if we treat it with respect and with preciousness it will somehow be more special and more precious. No, in fact, it won't be. If you want to make a photograph

special and precious, make a better photograph. The white gloves don't add anything to a bad photograph.

Why Are Photographs Quadrilaterals?

I love the way simple questions sometimes lead to complicated answers, which sometimes open the door to creativity.

Here's a good example of that. Why do you suppose all photographs are rectilinear, that is to say, they're all quadrilaterals, technically speaking? Why don't we have any photographs that are trapezoidal or parallelograms? Why is it so rare to find round photographs, or oval photographs? It's relatively easy to do these things. You can make a photograph any shape you want. But it seems like 99 percent of them are either square or rectangular. I'm wondering if this is a convention that is practical, or a convention that is aesthetic?

From the practical point of view, it's a lot easier to cut film square, and to cut prints square, but you know, lenses don't make square images. All lenses make round images. And as human beings we don't see in squares; we see in rather flat ovals, as you'll discover if you trace your peripheral vision by staring at a point and then seeing the shape of what you observe in the edges of your vision. It's actually an oval shape that we see.

So why are pictures square? As I say, an example of a simple question with a complicated answer, and maybe—just maybe—an opportunity for creativity.

Remembering Recent Losses

It's been a really tough few weeks for photography. We've lost recently Helmut Newton, and Henri Cartier-Bresson, Van Deren Coke, Richard Avedon, Eddie Adams. It's always tough to see people we admire so much in our craft go, as Ansel Adams said, into the final wash, as it were.

This is a really great time for photographers to take a moment, pull out a few books from the bookshelves, and take a look at the work of these photographers and writers and historians that we remember and whose work has influenced us, because we owe these people a great deal of gratitude and respect for what they accomplished in their lives that has fueled our lives, motivated us, given us higher standards to aim for.

It's never asking too much to show gratitude to these people, and quite honestly, I can think of no better way for fans of these photographers and individuals to spend a little time with their work and remember what they gave to us.

Fog

Well, this is a rare treat. I get to combine two of my favorite topics of all time: photography and Charles Dickens. I'm going to read a little passage from Charles Dickens, because it has something to do with my topic of the day:

"Fog everywhere. Fog up the river where it flows among green aits and meadows; fog down the river, where it rolls defiled among the tiers of shipping and the waterside pollutions of a great (and dirty) city. Fog on the Essex marshes, fog on the Kentish heights. Fog creeping into the cabooses of collier-brigs; fog lying out on the yards, and hovering in the rigging of great ships; fog drooping on

the gunwales of barges and small boats. Fog in the eyes and throats of ancient Greenwich pensioners, wheezing by the firesides of their wards; fog in the stem and bowl of the afternoon pipe of the wrathful skipper, down in his close cabin; fog cruelly pinching the toes and fingers of his shivering little 'prentice boy on deck. Chance people on the bridges peeping over the parapets into a nether sky of fog, with fog all round them, as if they were up in a balloon, and hanging in the misty clouds."

I read this passage from Dickens because I love fog. It is one the most photographic things I know of, and when I find fog—like it is this morning—creeping into my little neighborhood, it is such a temptation to run out with the camera because when somehow the atmosphere becomes alive with fog, or clouds, or rain, or lightning, or dust blown in the air, or high, puffy clouds in the sky, that's the time when great photographs could be made outdoors. Isn't it interesting what an important component of photographs is the simple atmosphere in which we live, that's supposedly transparent but becomes alive in a photograph when it's not.

Passion

There is no question in my mind that in the creation of artwork, talent has a place, and technical skill has a place, and practice and repetition and lots of other characteristics have a place. But the most preeminent personal characteristic necessary for the creation of artwork is passion. Without passion about what you're doing, you can't create great artwork.

My reason for this thinking is illustrated by this example: Imagine, if you will, two people who decide to build a doghouse for their dogs. Both guys are talented carpenters. One guy would rather be doing anything else in the world than building a doghouse, but he's

doing it because he has to. The other guy is building a doghouse because he loves building doghouses—he has a passion for building doghouses—and he puts his entire creative focus into building the best doghouse he possibly can. The other guy sort of goes through the motions, building a doghouse just good enough that it will do the job. Who's going to make the better doghouse?

It's a silly example in some regards, but it illustrates the point that the individual who has passion about what they do is, almost without exception, going to make something better than the individual with no passion.

Well, what about if one guy has incredible talent, but he's passionless, and the other guy has great passion but no talent? Who's going to build a better doghouse? I'm still going to bet on the guy with passion every time, because my experience has been that the guy with passion who pursues excellence at all costs, who lives, eats, and breathes doghouses, as it were, is eventually going to develop the talent and skill and the technical expertise to surpass the individual who's sort of coasting.

Passion: It's the most important element that I know of in the creation of artwork. And doesn't it then seem like a natural consequence that the best photographs you make will be the things you're most passionate about? Go photograph those things you really care about deeply and they'll probably be much better photographs than those you make of things about which you are not truly, deeply passionate.

The Single Image in a White Bevel Mat

Yesterday I did something I haven't done for several months. I matted three photographs. I haven't matted a print for quite a while. Not that matting prints is unusual; I just haven't done one

for about 90 days or so. And I had a very interesting emotional response to the matted print, and I'm not sure how to deal with it. I looked at the matted print and my first emotional thought, which I can't deny, because it was there, was, "This is primitive."

This white mat board, bevel-mat-cut business about presenting a photograph, felt like something from the '70s, and in fact it is something from the '70s. And I guess maybe I felt this way because I'm starting to think and see photographically more and more in terms of groups of images. I'm thinking now in terms of storytelling with an image, where I need four, five, six, eight, ten images to do a better job of telling a more rounded story.

To take one image and put it in a mat board just felt somehow incomplete. It's probably just fine for décor; I have no doubt about that. But to use photography primarily as a means to decorate the walls is somehow starting to feel demeaning to photography. It's as though somehow it's not using photography to its ultimate capacity and capabilities, to use it as mere wall covering.

I don't mean to call into question the use of photography for décor; that's a fine use for it. But I'm saying for me, for the kinds of images that I'm doing, more and more frequently I'm finding the single image, all by its little lonesome self, and a mat board, just fails to give me the inspiration, the emotion, the power of the content, the impact that I know I can create by putting together more than one image in a presentation, be it a book, be it a montage, be it a triptych, be it a photo essay, a DVD, a Web page.

There are now so many other ways to get images out, and ways to use photography to explore the human condition and to share human emotions, that somehow the single image in the mat board is feeling like a limitation rather than a rule of thumb.

Don't Bother Sending Prints

I was off this weekend at a family gathering and I had a very interesting conversation with one of my relatives. Of course, as the photographic publisher and photo person of the group, as many of you can relate to, I'm sure, I'm always elected to do the family photo, which I did.

I shot this one on my digital camera, and one of my family members came up to me later and said, "Oh, shoot, I wanted you to take the picture with my camera too so that I could have a copy of it, and I forgot."

And I said, "Don't worry about it; no problem. I'll send you a print from the photographs that I made that are in my digital camera."

And she said something very interesting. She said, "You know, rather than having a print I'd rather have the digital file, if you wouldn't mind just e-mailing it to me. That way I can do my own printing and my own cropping and adjusting of the image."

And I thought, "Isn't that interesting that we've gotten to the point in photography now, with digital cameras and whatnot, that people don't want prints anymore; they want your negatives."

I was happy to do it; that's just fine. But I did think it was an interesting shift of some historical note, and it does make me wonder if at some point down the road we photographers will not be distributing prints of our fine-art photographs, we'll be distributing the digital files so that people can make their own prints. What a weird concept. But I'll bet you at some point in time, it's coming.

Using Your Image Database Creatively

More and more I find myself interested in groups of photo-

graphs rather than individual photographs, and one of the interesting aspects of this has to do with, of all things, database management. I started creating databases of my negatives in images some time ago and I've extended that over the years, and now with the digital images that I'm making, that database is turning out to be even more useful.

One of the things I've learned about working with groups of photographs is that most database software tends to force you, or at least encourage you, to think about making database groupings based on the subject material. And it's very useful to divide files of images or database images into folders of similar subject material, or folders of a specific location or a time that you photographed.

But I've found that there are some other ways to think about photographs in terms of database and being able to put together and assemble groups of photographs (even just for the project of thinking about things), that is not necessarily intuitive based on the database software that I've been using. In addition to just subjects, one of the things that I've found particularly useful is to keep a database entry for every image about the distance that I was to photograph—and not the focal length of the lens, but the distance. Was I very close to it? Was I far away? Was I distant?

And so I have a field in my database where I can choose either infinity, 20 to 50 feet, 10 to 20 feet, three to 10 feet, closer than three feet, macro, and super-macro. And it's amazing how useful that is in putting together groups of photographs that I wouldn't necessarily have related before.

I also have a database field for primary colors, and I keep information about whether or not an image is primarily warm tones, cool tones, saturated colors, pastel colors, or monochromatic colors. Now, most of my finished artwork is black-and-white, but nonetheless, keeping this database in terms of colors has been very useful in terms of finding images that go together in groups that I wouldn't necessarily think of.

The third database field is compositional shapes, so I keep track in the database whether or not the basic composition of an image is round, diagonal, a T, an L, or a random shape. So now when I'm working with my database I can find a subject that has a certain distance, and a certain set of primary colors, and possibly even a basic compositional shape.

In putting together the database of my images this way it's been fascinating to see how many times I repeat the same pattern visually in different subject materials, or how many times I tend—in a rut, to be honest—to approach a given subject in the same way, and it helps me break out. It's worthwhile thinking about how you organize your images in your database, and how you gain access to those images, in ways that allow you to think differently and more creatively about your own photographs.

Girl with a Pearl Earring

I watched a fascinating movie last night that I wish I could recommend, but the movie itself wasn't that good. It's called *Girl with a Pearl Earring*, starring Scarlett Johansson and Colin Firth. The basic plot line in this movie, which deals with art and artmaking, is the inspiration that the Dutch painter Vermeer received from the little peasant girl who ended up posing for this painting.

I have no idea whether this is a historically true account of how this painting was made, but it is a painting I'm familiar with—I've seen it reproduced in books—and so I thought it would be an interesting movie. The problem with the movie was that the musical score was miserable, the plot line was difficult to follow, and the directing was suspect—but the idea that every artwork has a story behind it is a potent idea.

This is one of the real challenges of going to a museum or a gal-

lery exhibition. It's the role of the docent to educate us about what that story is, and how the work came about, and a little bit about the history of the artist, and the place of this particular piece of artwork in the context of history, and the artist's personal history. All those things are an important part of understanding a piece of artwork. But the problem is this: What happens when there isn't a docent? What happens when there isn't a book? What happens when a photograph is just hanging on the wall somewhere in a gallery, in a museum, in someone's home, in your home? How does the story that enriches and enlivens the piece of artwork get told, not as part of the artwork but about the artwork?

It's an interesting question, and one that's probably worth spending a little time thinking about. I don't have any solutions right now, but I know it's a question I'm going to be trying to answer in the coming months, because I think it's an important part of presenting artwork.

Apprenticeship

Don Worth, Ted Orland, Alan Ross, Chris Rainier, John Sexton. What do these photographers have in common, other than the fact that they are all terrific photographers?

If you don't know Don Worth's photographic work, you need to search him out. He is a terrific photographer. Same with Ted Orland; same with Alan Ross. Chris Rainier has a new book coming out, and of course, John Sexton is probably well known by most *LensWork* readers because we've published him before, as we have Chris Rainier. What do these photographers have in common?

They share the value of the lesson and the sadness that I have: that the apprenticeship idea has died out in the arts-and-crafts

world. It's almost impossible to find someone you can apprentice with or learn from.

All of these photographers were at one point in their career assistants to Ansel Adams. They provided labor for him, and in exchange he educated them—they couldn't help but learn in the process of being a laborer for him. As a result, they've all gone on to be really terrific photographers.

It's really too bad that the idea of apprenticing with a master photographer has dried up and blown away. Now we all go to school, we go to an MFA program, we learn from some teacher. You know, teachers are good, but they're not master photographers and they cannot replace that hands-on experience of working with someone who's doing it, of being there day in, day out, during the hard parts, the easy parts, the grunt-work parts, the flashes of insight, the drudgery of the hard work. That's what apprentices do, and I think that's an incredibly valuable lesson.

I wish we still had a strong apprentice program in this country. They do in Japan, and some of those Japanese artists are learning things that are mind-boggling. Too bad we don't have it here.

Paper Sensuality

I've become fascinated again with paper. Paper is just such an incredibly marvelous thing: the texture, the color, the weave, the thickness. Paper is so sensual. It's such an important part of the photographic process. I remember when they introduced RC photographic paper—that plastic slimy stuff—in the 1970s. It never really did become very popular with those of us in the fine-art community, because it was just so sleazy. We all wanted good fiber-based paper, because paper is such an important part of a photograph.

In the world of printing digital prints on an inkjet printer, paper becomes an incredibly important component. It dawned on me that I've never had much choice about paper surfaces and textures in the traditional papers that are available in the wet darkroom. The manufacturer determined what paper was going to be used, and what color was going to be used.

For example, when Forte and Ilford introduced a warm-tone paper that had a slightly creamy base, a lot of us were applauding because, for the first time in a long time, we had a really terrific photographic paper that wasn't arctic white, or even a little bluish-white.

Now that I'm starting to experiment (a little bit tentatively) with inkjet printing, I'm realizing the world of paper is opening back up to me. There are so many different kinds of paper. It's really confusing and a little bit boggling to try to figure out which paper to use with which inks, and what works and what doesn't, and what looks good and what doesn't, etc.

It's going to take me a while to work through this, but when I'm done I'm going to be able to introduce the sensuality of paper back into my photographs. And I'm really looking forward to that. There is something really magical about having a photographic image on a very sensual paper.

The Magic of It

A number of years ago I was visiting the Art Institute of Chicago and I found myself absolutely amazed by a medieval suit of armor. And even though I'm not very interested in that era of history, I found myself amazed at this particular artifact from that era, because my mind could not grasp how they could do that kind of work—let alone do that kind of work in their day. And

as I looked at this suit of armor I realized that one of the keys to being amazed at a piece of artwork is not being able to figure out how they did it.

I got to thinking about this relative to photography and I realized that my parents, back in the '40s and '50s, had a camera and made snapshots. But when they looked at an 8x10 that was done by an artist, they were amazed that the artist could produce that work. It was magical and mysterious to them—how to make that gorgeous, detailed 8x10 with such subtle tones, that was way beyond their capabilities—that photographic artwork to their generation was absolutely magic.

But the march of technology has made it easier and easier for us to make really stunning 8x10s. I've had this conversation with a friend of mine who makes very large, beautiful color images, and very few people when he started doing this could even approach what he did. He was literally, I think, the finest color printer in the world. But I told him at that time, "Watch out, because it'll only be a matter of time before anybody can make an image, technologically, that will compete with yours, because the march of technology will catch up with you, and when the march of technology catches up with you, then your images won't be magic. They'll just be pictures like everybody else does, and when the magic of it disappears, that's dangerous turf for us photographers."

Imagine the photographic tourist standing on Wawona Point overlooking the beautiful Yosemite Valley. He stands there with his 35mm camera strapped around his neck and says, "Oh, I can take a picture of this that'll look just like Ansel Adams'." And he picks up his camera, and he points if off at the valley, and all of us photographers laugh at this individual because we know that this person cannot make a picture that looks like an Ansel Adams photograph with the 35mm camera strapped around his neck.

But what happens when the march of technology is such that suddenly he can make a picture that's as good as an Ansel Ad-

ams? This is not just a theory. We're essentially at that point now. An awful lot of cameras that consumers would use could make a picture that's as good as an Ansel Adams photograph from a technological point of view, assuming that they had the right kind of light, and the right kind of atmosphere, etc. So it's not inherent as photographers anymore that our images are to be technologically better than everybody else who has a camera.

This is not the case when we look at painting, or a beautifully crafted piece of jewelry, or a woodcarving, or, probably the classic example is music. We know when we look at this artwork that we can't do it, and as a result of that we're mesmerized by what these artists have done, and we respect them. That can't so easily be said about photography, because when the amateur says, "Oh, I could do a picture as well as the artist," they're probably right in making that statement.

Now, here's where it gets really interesting to me, because that implies that the true art of photography is not technologically based, but it is a statement that we make about humanity, the human condition, the expression of our internal creativity. So our art is not in machines—it's in us.

A better example for us to consider when we're thinking about the creative process is not other technology-based arts, like painting or wood carving or music, but the kinds of arts in which the tools are available to everyone. So consider for just a minute writers and poets. They have access to the same words that you and I do, but what they do with them sets their work far above ordinary conversation. By the same token, the cameras that we use are available to everybody; the printing technology that we use is available to everybody; just like the words that the poets and writers use are available to everybody.

What makes our work rise above the snapshots and the pictures that everybody else can make is the same creative process that makes the words that the writers and the poets use rise above

ordinary conversation. There is a lot for us to learn by examining the creative process of those who use words to make artwork.

Your Contemporaries

I was showing my photographs at a workshop when the discussion of fellow travelers came up. This is sort of standard workshop fare, the questions being, "Who is out there in the world who's doing work similar to the work that you are doing? What can you learn from them? What did they do successfully that you might take a look at, etc.?"

In that conversation, the workshop instructor mentioned to me in looking at my work that a fellow photographer of mine might be Walker Evans. Well, that was a compliment. I like Walker Evans' work; I felt good about that.

And then he made a statement that really set me back, because he said that I would need to improve my work dramatically if it was going to survive in history, because I would be judged as a contemporary of Walker Evans. Of course, at first glance this didn't make any sense to me because Walker Evans made a lot of his great photographs in the '30s and '40s. Here I was photographing in the '70s, '80s, and '90s. But he said, "You know, you have to look forward 200 or 300 years. In 200 or 300 years from now, you will be seen as a contemporary photographer of the American scene, contemporary with Walker Evans, and Dorothea Lange, and the FSA photographers."

From that perspective of 200 or 300 years in the future, he's right. We tend to think of Michelangelo and Leonardo da Vinci as contemporaries, but in fact Michelangelo came considerably after Leonardo in history. But in our minds they come from about the same time. I find this an interesting thing to think about, because

when you step back and look at your own work in the larger context of history, to me it's motivating, because I realize the importance of producing work that stands up to an historical standard of the best photographers that have been photographing before me.

In that context it makes me motivated to do a better job than I would do if I were just comparing myself to my friends, to my peers, to my own previous work, or to the work that I see exhibited in the galleries today that's similar to mine. No, I really should be comparing my work to the very best work in all of history, and that motivation is a terrific source of inspiration.

Edges

Years ago, I was talking with a photographer whose work I respect a great deal, and he said something to me that was exceedingly simple, but at the same time it's continued to plague my thinking for years and years now.

He said, "Watch out for the edges. Wherever there's an edge, there's an energy. That's what you want to be photographing." I thought this was interesting advice and I've remembered it all these years. And you know, I find it to be pretty good advice. When I want to go photographing, a lot of times that's what I do—I look for the places where there's some sort of edge or transition from one thing to the next.

The classic, of course, is the edge where water and land meet. You can make great photographs there, whether it's at the coast, or where there's a river or a pond, or some other place where water and land meet. Another is where land and sky meet.

This business about edges is not just where physical edges meet, but also where psychological edges meet: where anger meets compassion, where compassion meets sorrow. Wherever you find an

edge, look carefully. If I find myself in a place where I'm having a hard time making photographs—for some reason I'm just not seeing anything interesting photographically—I remember this advice and start seeking out edges, because I've basically found it true. Wherever there's an edge, there's an energy that can come forth in a photograph and make it more powerful.

The Edward Weston Exhibit

Recently there was a fairly sizable retrospective exhibition of Edward Weston's work at the Portland Art Museum, and a friend and I got to talking about whether or not we wanted to drive down and see the show. We agreed that we didn't, which was a surprise to both of us.

We got to chatting about why neither one of us wanted to drive the four-and-a-half, five hours down to Portland to see the show, and we were both amazed at the way the conversation unfolded.

First, both of us had seen major Edward Weston retrospectives before, and even though we both love the work and think it's terrific, the fact that we'd seen it before sort of got in the way of motivating us to see it again. It probably shouldn't have, in the sense that the second time you see work there are always new things that you see, and of course we've changed since we saw it the last time. But it was a little less motivating to go see it now than it was the first time, when we knew we would be amazed at seeing this master's work.

Second, we both have so many Edward Weston books that are so beautifully and wonderfully printed that we knew the difference between the images that we would see in real life and the reproductions that we saw in the books was relatively small. By looking at the book reproductions, we knew we were getting 95 percent

of what there was to get by looking at an Edward Weston original photograph. We couldn't say that when we first saw Edward Weston's work back in the '70s, because the printing technology wasn't as good back then. But today's books are so extraordinarily good that the difference between the original and the reproduction is relatively small.

One of the things that we found most interesting in this conversation was that we began to wonder what the implications of our decision not to see the show might have on museums and their interest in collecting work in the future. If lots of people didn't go see an Edward Weston show because they've already seen it before, and because there's nothing new to see, and for all the reasons that we had, then attendance at the museum show might be less than it was 30 years ago, when Edward Weston was really making a splash for the first time seriously in our generation. And if attendance in the museum show is down, would that lead them to think that interest in Edward Weston, or interest in photography in general, might be on the wane, which would reduce their motivation for purchasing, collecting, or exhibiting photographs?

It was an interesting train of thought to explore. The bottom line is, we didn't go see the Edward Weston show. And although I suspect I didn't miss anything by not seeing it, I don't really know for sure, so I've got a little tiny bit of guilt about not having seen it. But if I received an announcement today that the show had been extended, I'm still not sure I'd go.

Outtakes

On occasion, when we watch a comedy, either on television or a DVD, there will be at the end of the movie a section called the outtakes. And I don't know about you, but I find this to be the

most entertaining and oftentimes the very best part of the movie. The unexpected comedy in the outtakes just slays me. I think it's wonderful stuff. I love the bloopers shows on TV, those accidental, unexpected, absolutely hilarious moments when you get to see the actors cut up and be natural, be themselves, be something that the script did not anticipate.

Strange as it may sound, I think there is an application for this in photography. I don't think the same sort of comedic relief can be had by showing the outtakes of our photographs in a project, but I do think that the outtakes can be a very interesting part of what we've produced.

For example, why does a photographic project have to consist of only the really terrific photographs? Why can't we also include some of the outtakes? I'm thinking specifically of Web sites, of CDs and DVD projects, the kinds of presentations where you can easily separate the main body of work that you're intending to show from a secondary body of work that is perhaps put there for the fun of simply sharing some images that didn't make the final cut.

Oftentimes a photography project of substance consists of hundreds of images that you've made, of which maybe a dozen, or two dozen, or three dozen end up in the final project. Well, what about the other 70 images? Maybe some of those are really terrific images, but they didn't fit the sequence, or they were too close to an image that was selected, but a variation on the theme might actually strike someone else as more interesting than the one you selected and edited for the project.

I think there's a place for outtakes in some photography projects. Maybe they're not appropriate for the gallery walls. But as we start exploring other alternatives for the presentation of our photographs, there might just be a place for us to put outtakes and add a certain element of spontaneity to the work, and a behind-the-scenes look at a photographer's creative process.

Muscle Memory

By sheer coincidence, I haven't had a chance to work in the darkroom for the last couple of months; I've been busy doing some other things. I finally got a chance to get back in the darkroom, and in this particular case, I was starting to print the Wynn Bullock folio that we're publishing. This involved printing about 800 prints in a matter of a week or so. The reason I bring this up is because there was a lesson involved in it.

In the first couple of days, involving some pretty long hours in the darkroom, I was absolutely miserable. My back hurt, my shoulders were sore, my neck was just killing me at the end of the day. I spent a lot of time on the heating pad. You wouldn't think working in the darkroom would be that physical an activity, but when you're trying to do that many prints, and work that hard and that long without a break, it can be pretty exhausting. For a couple of days I was pretty miserable.

Then I got my rhythm, and I got my muscle memory back, and I got over the soreness of bending over the darkroom sink, and my back loosened up a little bit, and in the next couple of days I started to feel a lot better. And it reminded me how many times it is in life in general that we start something new and we find for a couple a days we are really sore, and it's really hard—whether it's golf or painting the house or any other physical activity that requires using some muscles in ways that we haven't used them before.

The same thing happens when I'm out photographing. On a long trip, the first couple of days I'll actually be a little sore, a little stiff, a little cumbersome, a little clunky, a little awkward, and it's because I haven't got my muscle memory back, and I've learned that I have to be patient. If you want to be good at something, if you want to be skilled at something, if you want to be smooth at something, you have to give your body time to get adjusted to the motions and the movements. And with a little patience and perse-

verance, I'm delighted to report that eventually you start feeling a little better, and it all works out in the end.

Color and Emotion

Let me challenge you for just a second with a little game. I'll name the color, and you name the emotion that goes with it.

What emotion goes with yellow? Well, that's probably happiness. It's the color of sunny times. What about green? Well, green is the color of envy or jealousy. And red? Red is anger. Now we come to the crux of things: What emotion is associated with 60 percent gray? Or zone five? Or zone two? Or zone seven?

Isn't it interesting that black-and-white is an absolutely emotionless color palette. That's one of the great challenges we have as black-and-white photographers. We don't have this inherent emotional content that goes with the colors. We do, however, have tint as an application of color in a black-and-white photograph.

This is one of the reasons why I've always been fond of warm-tone prints, because warm-tone prints, even though there's not a color involved with them other than the slight warmish hue, tend to be slightly emotionally warm and accessible. It makes them a little more inviting.

Conversely, there's nothing worse in my opinion than a slightly greenish print, the kind of green that you get with gelatin silver before it's toned. Untoned black-and-white prints, with that greenish cast that you get with gelatin silver, tend to be just a little green around the gills.

Listening to a Movie

I did something quite odd the other day that I thought I'd share, just because it—well, because it amuses me to do so. I listened to a movie.

I was in the darkroom working. It had been a long day, and I was kind of tired of listening to some music and other things, the radio I had on, etc. So I popped in a DVD, which I could not watch because I was printing in the darkroom, but I could listen to it, just for fun.

I was amazed how effective it was, listening, ears only, to the movie. This is one of my favorite movies. I've watched it a number of times, and as a result I could bring forth in my mind's eye every single scene, every single nuanced movement the actors made, the close-ups, the distant scenes—I could see it all. And I could bring forth those visual images in my mind in real time as I listened to just the soundtrack.

Now, what's so interesting about this is I'm wondering if it's just me, or if it's everybody. Do we all have such a direct link between our auditory senses and our visual senses, or is this just me? My wife and I have talked about this. She does not learn very well listening in class or listening to a lecture, but when she reads something it sticks. In my case, when I listen to a lecture, an audiotape, or something like that, it really gets into me somehow.

Different people learn differently; that's fairly obvious. But one of the implications I became aware of as I was listening to this movie is how powerful the connection is between what I hear and what I see in my mind's eye. And I'm wondering if there might be some application in photography. That is to say, what would happen if I recorded a photographic session and then played that soundtrack back while I'm printing in the darkroom? Weird thought, but I think I might just give it a try.

The Unknown Photographer

Of course you all remember that great photographer, Sam Shere.

You don't?

Who?

This is one of the most interesting things, because we all know the great photograph that Sam Shere made. He's the guy who made the great photograph of the Hindenburg exploding and crashing in flames. You know the image. I mean, it was on the cover of a Led Zeppelin album. Of course you know this image. But isn't it interesting that we don't know the photographer who made the image? At least I didn't until I happened to be looking at a book of historic photographs and it gave the name of the photographer, in this case Sam Shere, a guy I'd never heard of before.

I have no idea if he made any other interesting photographs, but his place in history is cemented with the strongest visual superglue, because we all remember that image. That's one of the things about being a photographer, about being an artist, is that the product that we make may be way more famous, and way more interesting, and last longer than the memory of the artist who made it.

I don't think this is necessarily a bad thing. I do think, in some sense, it's something we might strive for. I would rather be the photographer of a really wonderful image, who spends eternity unknown, than a photographer that everybody knew but who never made any interesting images. Just my personal preference, but my hat's off to Sam Shere.

Research

I used to think that making photographs meant getting in the

car and driving around until you saw something that inspired you in the landscape. That's probably a perfectly good method. I still enjoy doing it. It's a great excuse to get out in the car and drive around, see the country—nothing wrong with that.

But more and more I've come across the idea, as I've talked to people about their process and interviewed them for *LensWork*, that one of the important ingredients in making a successful photographic project is research.

I talked to a friend the other day who's doing an interesting little project photographing forks, and in order to be prepared for this project he did a fairly extensive research project on forks. He learned where forks came from, how they got introduced into the culture, what they originally looked like, etc. There was a project involved in his mind in learning what forks were and where they came from before he could photograph them. And the process of doing the research has given him additional inspiration.

Back in *LensWork* #31 I interviewed a photographer named Terry Vine who photographed extensively in Mexico, and before he went, months before he went, he developed a list of all the things that he wanted to photograph, based on his research of the town, the specifics, the culture, the events that took place in the particular place that he was going to go photograph. He had a sort of a hit list of things that he wanted to photograph when he was there. So when he arrived in the location to do the photography, he already had an extensive self-assignment of things he wanted to photograph that were likely to be a part of the project when it was all said and done.

This idea of self assignment combined with research is a very fruitful one. It's an idea that has inspired me to think differently about how I photograph, and more precisely, how I prepare to photograph.

Looking the Part

A friend of mine is a professional photographer—shoots weddings and portraits and that kind of thing. He decided to start using a digital camera for some of his images, and when we talked about it I advised that he could probably get all the image quality he needed out of a camera that's known as a "pro-sumer" camera. So he bought that, and he's been just thrilled with the images that he gets. He loves it, his clients love the pictures, everything's been just fine.

However, he told me the other day he's decided to buy a new camera—a digital SLR camera—not because he needed it, not because the picture quality was going to improve with a better-quality camera. He decided to buy it for one simple reason: The more expensive camera would help him look more like a professional.

Even though he's been in the business for 30 years, there were some people he was photographing who seemed not to be very impressed with the equipment that he was using and were questioning his professional qualifications or status. So he's getting a bigger camera, for no other reason than it will make him look more like a professional photographer.

As much as I find this a little bit bothersome, that we have to put up such a ruse, it is true that perception is an important part of a professional's life. I know when I go in to photograph something—even as a fine-art project—if I look the part of a photographer it's a lot easier for me to be accepted as an artist. It's silly that it should be this way, but that's the way the world works.

Digital Media in its Own Right

A friend of mine recently sent me a little PDF project that he

had done to show some of his platinum palladium work. He asked for my opinion of it, and the photographs themselves were just fine, but my first thought when looking at the PDF was to question why I was seeing images in what, for all intents and purposes, looked like a presentation in mat board.

The image he wanted me to look at was centered in the screen, surrounded by white, slightly higher than dead center, and positioned on my computer screen where it would have been had I been looking at mat board. And I thought, "This is odd. This is not taking advantage of the medium for what it is."

I suggested to him that he might think about not making his PDF presentation a copy of his platinum palladium prints, but rather using it as a medium in its own right. That is to say, why do digital photographers try to make inkjet prints, for example, that look like gelatin silver prints? Why not make inkjet prints that look like inkjet prints? Each medium has its own virtues.

The computer screen has things it can do and ways it makes images look that can't be duplicated in gelatin silver, or on inkjet, or in any other medium. A PDF presentation of photographs is its own medium if we approach it that way. So, rather than make a Web site that's a copy of your original photographs, make a Web site that's a Web site. Exploit each medium for its virtues. To do otherwise is as silly as working tirelessly to make a watercolor look like an oil painting. Learn to use each medium for its own inherent strengths.

The Chip-Away Philosophy

When faced with an overwhelming project, I've developed a strategy that I call the "chip-away philosophy," and we use it a lot around here. It's simply the understanding that giant projects that

are overwhelming, and going to be difficult and time consuming, are a lot easier psychologically—if not logistically—if we divide them into smaller parts.

So we chip away at things; we do a little bit each day; we move the ball ahead—an old football analogy. You can't score a touchdown every time you throw the ball, so instead you gain a few yards, gain a few yards, and eventually you get there.

Well, exactly the same thing works in developing an art project. I've learned that I can't produce a full photographic art project in one sitting, or even two sittings, or sometimes even a week or month. Some projects are just larger than this, and in order for me to accomplish them I have to chip away at them over a period of months or even years.

The reason I bring this up is because there's a crucial part of this philosophy that most artists don't consider, and that's this: In order for the chip-away philosophy to work, you have to have the final vision, the final product, the end of the project in mind before you start. If you're going to chip away a little bit in the beginning and it's going to take you months or years to accomplish it, the way it's going to look in months or years needs to be firmly planted in your mind's eye so that the work you do today actually does lead to productivity and usefulness a year from now when you're doing the final assembly.

So, one of the things I've found useful is to use this philosophy in little steps. Think in terms of small projects, but then visualize the end result and then sneak up on it in little steps. Chip away. It sounds simplistic to approach an art project this way, but it's amazing how productive it is when you do a little bit on a regular basis, rather than trying to do a giant amount all at once.

To Be Uncompromising

One of the odd things about being a publisher in photography is the fact that we're not the only publisher in photography. A lot of times we receive a submission here at *LensWork* which we eventually reject because the work isn't, I'll say, deep enough.

That is to say, there are three or so really terrific images in the body of work that's submitted, but ultimately, when we look at the rest of the work and try to put together a selection of 15 or 18 prints for a portfolio in *LensWork*, we find that once you get past those initial three it gets pretty thin pretty fast. Oftentimes we'll see that same photographer's work appear in some other publication in which they'll have three images—the same three images that we thought were killer images, the other publishers think are killer images, and so there it is. You have a photographer with three images and golly, it looks fantastic. And it is fantastic as far as it goes.

The challenge for creative photographers is not to come up with three killer images. That's—well, I don't want to use the word easy, because it's not easy—but it's not enough to explore a theme or a subject or to put together a body of work based around three really great images and a whole bunch of images that are sort of filler.

The real challenge of being a creative photographer is coming up with not three killer images, but 18 killer images, and that's a much, much more difficult thing to do, and one in which we have to push ourselves. We have to not compromise, we have to really explore creatively, not allow ourselves to become satisfied when it's just okay, but to recognize that excellence itself is the challenge of being a creative artist, and anything short of pushing and pushing and pushing, and striving, and being uncompromising, is a compromise in your artistic life as well as in the body of work.

Display Rails

I received an e-mail from one of the commentary listeners who posed an interesting question. He was curious about how I display images in my home. He had received a Christmas present of a framed print and described trying to find a place to put it in the house. It was a rather large print that would normally fit on a wall, but lighting and access for him to be able to see it on a regular basis were a problem.

All of these are issues that we can all relate to when it comes to framed prints. So I described to him a technique that I picked up a number years ago from my friend Morrie Camhi. He had a unique way of displaying photographs and artwork in his house that I thought was just wonderful.

He either had manufactured or built himself a very simple wooden rail that went all the way around his living room at just the right height for viewing artwork. It was about five to eight inches deep, and he could put on this rail an individual print, a matted print, a framed print, or a piece of artwork, a ceramic—anything like that that he wanted to put on display and have in his living room for a while.

By not hanging the prints on the walls, he didn't have a permanent installation of his photographs and artwork. He could change them easily through the seasons at whim, when he was working on something new that he wanted to put up and look at for a while, while he tried to decide if he had it finished and complete or not.

It was a great, flexible way to see artwork, to have it constantly changing, being updated. We've adopted it here in our house, and we really like it, because we can refresh our artwork on a whim without having to pound a bunch of holes in the wall, and hang prints, and worry about whether or not they're straight. It's such a wonderful way to display artwork that we use it not only in our

home but here in the *LensWork* offices and in our gallery down-stairs.

My New Year's Resolution

I had to chuckle the other day, because I spent a couple of hours getting some really productive stuff done—or so I thought. A friend and I have laughed about this over and over, to the point where every time I do it, it reminds me of our conversations.

You get to that point where you think, "I've just got to get organized," and you sit down and spend a couple of hours cleaning your desk, organizing your papers, developing your to-do list, and when it's all said and done you really feel like you've accomplished something.

But then I find I really haven't done anything. All I've done is organize my to-do list. There is a procrastination element in this, and I'm so plagued by this that a number of years ago I read a book on procrastination and perfectionism, and it gave me one very interesting little seed of an idea I'll plant here, in case some of you have got New Year's resolutions that might pertain. This book proposed that the only practical outcome of perfectionism—the oppressive desire to do things perfectly—is to not do them at all.

And I must admit, there's a certain part of me that struggles with this. I want to do things right, and if I can't do them right, I'd rather not do them at all. If I can't do them beyond criticism, at least by not doing them I can't be criticized. So procrastination and perfectionism go hand in hand—two sides of the same coin.

But in the real world, it's almost always better to do something than to do nothing, to get something finished than to get nothing finished perfectly. Maybe I haven't stated this idea in the form of a New Year's resolution. I resist such things, to be honest with you.

But it is the closest thing to a New Year's resolution I have. I'd like to let go of procrastination, and in the course of doing so let go of perfectionism, and instead follow that old rule of thumb that says, "Pursue perfection, but be willing to accept excellent accomplishment as a compromise to stagnation."

Process Influences Product

One of the most overlooked ideas in photography is how much process influences the product. I have a friend who converted a number of years ago from doing silver prints to doing platinum. He just absolutely fell in love with the platinum palladium process and the look of a platinum palladium print.

One of the implications of this shift in his process was the change in his product. Before, he would often make 11x14 and even an occasional 16x20 print. Now that he's doing platinum palladium work, all of his prints are 4x5 contacts and 5x7 contacts. He even had to go out and buy a 5x7 adapter for his 4x5 camera so that he could make slightly larger prints.

This is just one example of how the process one chooses to be involved in can influence the final result. Another, even more powerful example in today's world, of course, is digital. For those who choose to explore digital photography, either digital cameras or digital darkroom, the process changes so much of what we produce.

Here's a good example. I'm working on a project of images that I photographed recently in North Dakota. My intention was to do them in black-and-white, and I like them in black-and-white. But with a color inkjet printer I have the ability to produce them in color, too.

But I don't like them in color, and so I set that aside and fo-

cused on black-and-white. But in the process I discovered, almost by accident, a color palette that's about a fourth of the way between black-and-white and color. It's a color palette I've never seen before. The closest thing I can relate it to is hand-colored photographs with those muted colors that you often see laid on top of a classic black-and-white image.

This is a whole new palette for me, one that I really like—at least it's really working well with this body of work—but a palette I would never have had at my disposal in a classic black-and-white darkroom. So the process that I'm using for this particular body of work is going to end up changing the product that I end up with.

This is clearly an issue that I think is going to become bigger in our lives as our choices of process continue to multiply and expand, because now we have not only all the traditional processes that have been pioneered in photography for the last 150, 200 years, but all the new processes that are coming down the pike. The choices we have to make as photographers now are going to significantly influence the final product that we create, because of this forward reach where process influences product so dramatically.

Photography and the Gift Recipient

We've just concluded the big gift-giving season of 2004. The holidays are now over as I record this during the first week in January 2005. And I'm wondering how many of you either received or gave a photograph as a gift.

It's an interesting thing to be a maker of something like a photograph, because it's quite natural to think about giving someone a photography gift. It's something that comes from our heart. It's something that comes from our creative soul. And I suspect a number of you naturally think about this when it comes to gift giving.

One of the interesting parts about gift giving is that the most appropriate gifts are the ones that would be most cherished by the receiver. And in the spirit of true confession here, a lot of times I find that the person who is most interested in my photographs is probably going to be me—that a lot of the things that I want to photograph, and the photographs I want to make, no one else would have any interest in them.

I'm slightly embarrassed by the fact that so many of the images that I'm interested in making would not make good gifts at all, because no one else would be interested in them. And I find that that makes me wonder if I'm particularly egoistic in my choice of subject matter and the production of my artwork, or is it the nature of being an artist, that we make what fascinates us, regardless of whether or not it'll be interesting to anybody else?

I'd love to use my photographs more as gifts, but I have to admit that to a large degree this would satisfy my ego a lot more than it would delight the gift recipient. It's one of the vagaries of being an artist, but I'm afraid for a lot of us it's probably true.

Beyond the Photographic Image

I'm fascinated by one of the really interesting shifts I see taking place in photography right now. There was a time not that long ago when a photographer was a person who made photographs—and that's pretty much all we did. We exposed film, we made prints. If we were really craftsman-like, beyond the mere photograph we might actually train ourselves to do matting and possibly even some simple framing, but that was about it. Photographers were people who made photographs.

But now that's changing, and it's a fascinating thing to observe. The world of photography has been married to a large degree with

the world of computers. And now a lot of photographers are involved in all kinds of non-photographic processes that contribute to the production of their final work. There are layout issues, typography issues, even writing text that goes with photographs. There's book production and design. There's even poster design and other printed materials. All of these things require a skill and an expertise that a lot of us photographers don't have, but it would be awfully useful if we did.

So, I'm starting to pay more attention to these non-photographic skills. I know that even if I don't do the typography or the layout or the book design for things that involve my photographs, the more I know about those skills, the more I'll be able to contribute to the process in a meaningful way when I work with professional typographers or professional layout people or book designers.

Photography is in an age where it's a lot more than simply clicking the shutter and making a great print. Those are fundamental skills, but for those of us who choose to, there's a fascinating world beyond the photographic image that's very, very interesting.

Inkjet as Printing Press

I had a fascinating conversation with a friend of mine the other day. He'd just purchased a new Epson 4000 printer. This is one of the new yippy-skippy digital inkjet printers that a lot of photographers are using.

He had a very interesting take on why he purchased one. He said he didn't buy it as a replacement for his darkroom. Instead, he explained, he was interested in it as a replacement for the printing press. He has in mind all kinds of ideas and small projects he'd like to do that include everything from note cards, to small prints, to little book publications, keepsakes, etc., many of which are ideal

small-press projects not big enough or substantial enough to spend the time and money on a big printing project that maybe it just doesn't deserve. But there are small projects that he would like to do, and he said that was the logic for buying the printer.

Almost without exception, the photographers I've talked to who have embraced digital printing have done so as a replacement to the darkroom, and as such there is always the discussion about comparing what comes out of these printers to what comes out of a darkroom.

These printers don't make prints that look like they came out of a darkroom. A gelatin silver print or good archival Cibachrome print is not going to look like a print from an inkjet printer. But when you take it completely out of that context and think about it as a replacement to the printing press, these devices may be more interesting than meets the eye to those of us who have thought about them up to this point as replacements for the darkroom. I thought his take on this was a very interesting, and so far as I've heard, a unique observation about what these new tools are, or at least can be.

The Choice of Medium

In my last commentary I was talking about Epson inkjet printers and the comparison that inevitably happens when one starts thinking about these as a replacement for the darkroom. But inherent in that discussion is another thought I'd like to expand on, and that's the comparison of one medium to another in terms of image quality.

It's only natural when one starts using a new tool like this to compare it to all the old tools that we're familiar with. I know a lot of photographers are looking at Iris prints or inkjet prints or any

of the other new digital printing technologies, and the first thing they do is compare them to gelatin silver prints or to Cibachrome prints, or to type C prints, to see if they're as good as what we've been used to.

But that's really an unfair comparison in some regards, because the ruler that defines quality is a ruler that was developed with the previous medium. Can you imagine how bad gelatin silver prints must have looked to those people who were used to platinum palladium prints or albumen prints? You see, what we've been used to will always define the aesthetic for the new materials. But it's really not fair, because the new materials have inherent qualities that the old materials didn't, and vice versa.

One of the things that's going to have to happen with these new materials is a new aesthetic. Each new medium has its own strengths and its own weaknesses, its own aesthetic, its own look, its own feel, its own palette, its own way of excelling when compared to other materials. One of the exciting things about being a photographer today is that we have so many choices. You can make gum bichromate prints, or platinum prints, or even Parmelian prints, or gold prints, or gelatin silver prints, or now inkjet prints, because all of these media are available to us. And that is a very good thing.

Several years ago, a gallery owner related to me a fascinating story. We were at an opening where he was displaying a lot of the *LensWork Special Edition* prints, and at the time we had just introduced the *LensWork Photogravures*.

At the time, no one knew what a photogravure was, so I assumed he was going to spend a lot of time explaining what photogravures are. But he explained that was not likely to be as important a part of the conversation as I thought it was going to be, because most people couldn't tell the difference between one medium and the next. I was fascinated by this.

He explained that when people look at a gelatin silver print

and then go look at a platinum palladium print, 99 out of 100 people can't tell the difference. And he had discovered, as a gallery owner, when he would explain the difference between one and another they would kind of look quizzically and say, "But they look the same." And he would say, "No, the platinum palladium has a completely different palette and a different field. It's printed on a different paper." And as he would educate them about the difference between a platinum palladium print or a photogravure and a gelatin silver print, they would begin to see the difference, but only after he explained it.

We sometimes forget as photographers that our eyes are extremely subtly trained to see such things in prints, where the general public maybe won't, maybe can't, not because they're blind or ignorant, but because they're just not educated to see the same way we photographers are. So we get all excited about these subtle, subtle things between one kind of print and the next, or between one print we're making in the darkroom and the subsequent one that has a little bit of dodging and burning added or subtracted.

It's easy to get hung up on those little details and forget that what speaks to people is not the subtleties of the print but the power of the content, and the way the image relates to them and their life on an emotional level, not on the level of the subtleties of the medium. That's only the means to build the emotional content, but it's not the ultimate reason why people like or dislike an image.

Why I Don't Go to Gallery Openings

In the spirit of true confession, I want to come clean and say that I don't attend gallery openings anymore. I haven't, quite honestly, for many, many years. And I don't specifically because I've found them to be just about the worst way there is to look at artwork.

I suppose this is a way of confessing that I don't understand what openings are all about. To me, the reason to go to an opening is to look at artwork and to see what's new and what's exciting. But it's not—at least, not the way it's done.

Most gallery openings are so crowded, and there's so much buzz and hubbub and conversation, so much so that you can't really see the artwork very well. If you can, you're only going to stand in front of the artwork for a few seconds before it's kind of expected that you move on so that someone else can have a chance to see.

So I've concluded that openings at art galleries are not about art. They're about the social scene, about having a chance to meet friends, or be seen seeing artwork, or schmoozing and having conversation about the artwork, and it's all about people and being social.

And that's fine; it's more like a party than it is an art experience, and there's nothing wrong with parties. But if I want to go see artwork and take some time to actually look at it, and ask questions about it, and think about it, and allow myself to be placed in the point of view of the artist, seeing the world through their eyes, an opening is just about the last place I'm going to do it.

If I want to have a party, if I want to schmooze with some friends, if I want to have a social scene, I'll go to a party. I'll throw a party. Or maybe I'll even go to a gallery opening. But only for the social scene and the party, not for the artwork.

The Changing Nature of Magazines

Here's an odd observation about magazines. It used to be that years ago that I subscribed to photography magazines because I wanted to be informed about the latest gear or learn about new techniques or the news from the industry.

But I tend not to get that information from magazines anymore. Now I can get all of that information—a lot more quickly, a lot more conveniently—on the Web. If I want to find the latest equipment, there are a thousand and one places that you can go to get a review of the latest equipment and not have to wait for the magazine to come out that has the review of the camera you're interested in. If I need to learn a technique, there are a thousand and one chat groups and other archives where I can go learn how to do something I want to do photographically.

This is changing the nature of the publishing world pretty dramatically. Obviously, I'm not in the business of publishing a traditional-looking photography magazine, so I really don't have any insight as to how those businesses work. But I do wonder how they're keeping their material fresh and alive, because the nature of what a magazine is has changed so dramatically now that we're in the age of the Internet.

I suppose if one wants to think about this more clearly you only need to look at what Shutterbug used to be back in the 1970s, when it was a huge, thick, authoritative publication and had lots of used gear. It's the place we all went to buy used equipment. But of course, that was long before eBay.

Serial Publication

I've confessed before that I'm a big fan of Charles Dickens, and one of the things about the work of Dickens that a lot of people are not aware of is that his 600-page books, like *David Copperfield*, *Oliver Twist*, or *Bleak House*, were mostly written as serials.

They were published weekly in a series of installments in various magazines, and it was a very popular way to publish work and

to build what would eventually become a large body of work—a 600-page novel—to construct it in bits and pieces and parts.

I wonder if there's an application here for photographers. I wonder what would happen if you announced that you were going to produce a series of work, of which the first two or three images were currently available, and you were going to sell them as a series—one print at a time released over a period of twelve months or two years or some interval of time, in which people would eventually collect an entire body of work, one or two prints at a time.

This is not totally unheard of in photographic circles. There are people who have been doing things like a print-of-the-month club, as it were. And from those people I know who have done this, they universally report that it's been a very successful and functional way for them to produce the work, because it spreads the labor of producing it over a long period of time, as well as the affordability of the body of work over a long period of time for the consumer. There may be some downsides to this idea, but it's certainly one worth thinking about.

Unknown Symbols

I was doing a lot of traveling last week and staying in a lot of different hotel rooms, and I had an interesting observation, of all places, in the shower. One of the hotel rooms that I was in had a shower, sort of a tub-and-stall arrangement, one of those single-piece, injection-molded plastic deals.

I was fascinated that the walls of this shower were molded into the form of fake tiles. They had little vertical and horizontal lines to divide the wall into squares. And I thought, isn't that interesting that they felt it was somehow aesthetically important and pleasing to make fake tiles in the walls of this shower-tub combination.

But what got me to thinking was the symbolism that was involved in this fake tile. You know, if you'd never been in a shower that was made out of honest-to-goodness tiles, the way they used to do it ages ago, you'd have no idea why these grooves were molded into the plastic of the tub. This is the same sort of idea as the symbolism that's used on a lot of forms, where they put a little picture of an old-fashioned dial telephone, which is a meaningless symbol unless you happen to know about old-fashioned dial telephones and were born in a time when old-fashioned dial telephones were what telephones were.

By the same token, if you look at the fake tile impressions in the plastic wall of the tub you won't know what those are unless you happen to know the reference of the tiles. The same thing takes place in making artwork. All the time, there are symbols involved in the artwork that are only understandable, they only makes sense, if you understand the reference to which they hearken back.

We need to be careful of this. We need to use this specifically and with control in our images, because in making artwork a lot of times sarcasm or irony or even humor will depend on understanding the symbols. These are cultural things, and things all of us artists need to control or, at the very least, be aware of in the creation of our artwork.

The Magazine Rack at Barnes & Noble

During my travels last week I found myself sitting in front of the magazine rack at Barnes & Noble having a cup of coffee and scanning across all of the photography magazines that were there for my enjoyment.

I found the following: *Practical Photographer, Photo, Photo Effects, Digital Photo, Popular Photography, Aperture, American Photo,*

PC Photo, *View Camera*, *Practical Photography*, *Digital Photo Effects*, *Digital Camera*, *Digital Camera Gear*, *Digital Photography*, *Digital Photographer*, *E-digital Photo*, *Peterson's Photographic*, *Outdoor Photographic*, *Digital Pro Photo*, *Shutterbug*, *Digital Photography and Imaging Magazine*, *Digital Camera World*, *Photoshop User*, *Photo Techniques*, *Photo Life*, *Natural Photographer*, *Popular Photography*, and finally one magazine called *Picture*. *Gee*, I wonder what photography is all about, at least if you look at the magazines.

By contrast, there's also a section of magazines that's devoted to people who are writers. It's interesting; I didn't find over there a series of magazines called *Typewriter*, *Typewriter Today*, *Word Processing*, *Processing for Words*, *Word Processing for Writers*, *Word Processing*, *Scriptwriter Today*, etc., etc., etc.

Why is it that so much of photography and the photographic industry is tied up with gear? Is it possible that it's as simple as following the money, all of those ads for equipment are what funds magazines, and therefore there are all of these magazines with lots and lots of ads? I find it just as curious as can be that in the magazine-publishing business about photography there is so little about photographs.

Seeing When You're Not Looking

A friend of mine related a fascinating experience he had the other day, which I thought I'd share because it was just such a good one. He went to take out the trash, and when he got to the trash can he found that the lid of the trash can had been turned over and there was some frost on the inside of it. He was about to just replace it back on the garbage can, but something caught his eye, and he realized the patterns on the inside of the garbage-can lid were just spectacular.

He saw in them the potential to make a terrific backdrop for a series of work he's been doing photographing some botanical still-lifes. This defines, for me, what the eye of the artist is all about.

The eye of the artist is not something that you bring forth when you decide to go out photographing. If this is the only time you use your mind's eye to look for photographs, you might miss a lot of opportunities. This particular individual happened to see something at a time when photography was the last thing in his mind—he was just taking out the trash.

Yet, he is such a trained observer of the world, he's such a true photographic artist, that even when he's not making artwork he's seeing artistically, he's seeing photographically. I think it's just fantastic. I've mentioned before how the best creative ideas sometimes crop up when you least expect them.

If you can manage to get yourself into that state of mind where you are always looking artistically and photographically, you'll find the potential for making artwork crops up more frequently than you would ever dream. There are always things to see in the world if we just have the eyes to see them.

Where is the History of Photography?

I was talking with Bill Jay last week when I visited him down in San Diego. And one of the interesting things he was telling me was what has happened to the study of the history of photography.

When he taught the history of photography for 30 years at the university level, his was one of the few courses to teach that particular subject, and in fact, he said that there were only six courses that taught the history of photography at the level that he did at the time he was teaching.

At the time of his retirement a few years ago, however, his was

the only course left at the university level that taught the history of photography to the extent that he did. But what's even worse is that when he retired, his university completely abandoned the program. They just walked away from it.

I find this absolutely fascinating. Can you imagine politics being taught without understanding something about the history of politics, or religion being taught without something about the history of religion, or language without the history of language, or even fine arts being taught without the history of art? How do you teach music without teaching a little bit about the history of music?

Yet, how many hundreds of photography courses are there in the United States alone, for which there is no comprehensive history of photography being taught? I'll bet Beaumont Newhall and Van Deren Coke are rolling over in their graves.

Pay the Price

An accomplished, well-respected, and terrific photographer recently sent me a copy of his new book for me to take a look at, possibly for inclusion in an upcoming issue of *LensWork*. And I had to tell him that this body of work was one of the most repetitive, banal, uninteresting things I'd ever seen in photography.

The first picture was not very interesting. The subsequent 60 or 70 pictures were essentially variations on the same theme, so they were all repetitive, boring copies of the first one. And in the entire book I really only found three or four or maybe five pictures that I thought were interesting.

Obviously, this was not what the photographer wanted to hear from me, and of course probably has heard lots of other positive and complimentary things from other people. Art, as it were, being

in the eye of the beholder, I'm sure some people loved this work; I didn't. I didn't think it was very interesting at all.

And when I told him this, his response to me was, "But we spent a lot of money to print this book, and it's printed exceedingly well." To which, of course, my response was, "So what?" No one cares how much a project costs. No one who views a piece of artwork or a book cares how much it cost to produce. No one cares how much you struggled to make it. No one cares that you were standing in the freezing cold of an icy river in order to get a really crappy picture of an ice form on a rock.

The pain and suffering that the artist goes through is absolutely non sequitur from the viewer's point of view. It's interesting how often we think this shouldn't be the case when we are the one who has suffered so, and financially paid for a project. But it is the painful truth. If it's a bad book or a bad project, no amount of martyrdom is going to make it any better.

The moral of the story is very simple. If you want an easy life, don't choose the path of the artist. If you want a life full of accolades based on effort, same advice. Do the work and pay the price because you love it, because it won't influence anybody's thoughts about your work when you show it to them.

A Half an Hour of Darkroom Work

Sometimes we do things that appear to be normal until you stop and think about them for a second, and then you realize how truly weird they are. The other night we were going to go out to dinner, but we had a reservation that left me about a half an hour before we had to leave.

So I decided almost reflexively to work on a photograph. I sat down in front of the computer, I opened up Photoshop, I played

around with it for a bit. I made a couple of prints, did some more fussing around, made another couple of prints, and it was time to go.

And then it dawned on me what I had done. In a previous life, or so it seems, when I did strictly darkroom work in the process of making my photographs, like we all did, I would spend an entire Saturday working on getting some images. By the time I mixed the chemistry fresh, got everything to temperature, got the negative in the enlarger focused, made some test strips, made some test prints, then started dodging and burning and flashing and doing all the stuff you have to do, it was oftentimes hours before I had something that was close to a finished photograph.

And even then, at the end of the day I might have—if it was a good day—five or six or eight photographs on the drying racks. And then the next day I had to flatten them, and spot them, and trim them, and mat them, and do whatever I had to do.

Now I'm able to take advantage of a half an hour before a dinner appointment. And what's even more amazing is I did it without even thinking about it. But now that I stop and reflect, I realize what an odd thing that is and how different the world is now than when I got started in photography. I continue to be amazed at the technological shift that's happened in photography, and how that changes the way we work.

The Naked Photograph

I tend to have a very curious reaction now when people hand me a stack of unmatted, unmounted photographs. They tend to feel like work prints or test prints, as compared to finished artwork.

When someone hands me a stack of matted, finished prints, then I feel like they're finished. These are done, these are ready for

exhibition or hanging on the gallery wall—at least that's the way I've tended to look at photographs now for 30 years.

But I'm starting to see a very subtle shift, and I'm not sure what the implications are, but now when someone hands me a matted print, it still tends to look like an unfinished piece of work.

I think part of the reason I'm starting to look at photographs this way is because I'm seeing what so many photographers are doing beyond the mere photographic image when they're including layout components or text, or they're making handmade artist books, or they're doing some kind of design work that takes their photograph beyond a mere image plopped in the middle of the page.

That's still the essence of a good photograph, probably always will be. But I think we're rapidly approaching the point in which the great photograph plopped in the middle of the page is going to start to look a little naked. It's going to look not quite as sophisticated as a piece of work that has a little more to it.

Clearly, this can easily be overdone, and a lot of Photoshop workers are taking it to extremes. But I discount that as the newness of all of the new tools, and as time moves on and we develop a new aesthetic with these tools, I think we're going to see that the bare photograph is going to start to feel a little like student work. We'll see.

People and Place Diptychs

I was looking at a body of work from a photographer friend of mine the other day, and he did something that was very, very interesting I'd never seen done before. It probably has been done; I'm just not aware of it. He did a series of portraits of people who live in his neighborhood, but in finishing the presentation of this

work he didn't simply show a portrait of the person's face. He made diptychs, so that every finished piece of work was a combination of two images: one was an environmental shot of the place where this person lived or worked, and was people-less. That is to say, it was just the environment.

The second half of the diptych was the portrait of the individual. The combination of this was a very, very interesting presentation. Each picture in and of its own self was a very interesting photograph, but by putting the two together, the two halves of the diptych worked against each other—the portrait and the environment—to create something that was bigger as a whole than either of the parts.

Matter of fact, I found it to be a lot more powerful than a lot of work I've seen where the portrait is done in the environment so you get that sort of classic person in their surroundings. This body of work was a much closer point of view of the person, so you had a more intimate view of their face and their physical presence, but in the context of the environment in the diptych.

It was a really fascinating combination of presentation that took these two separate images and put them together. I particularly love the fact that it was such a simple idea in terms of the construction of a finished art piece, but so doggone effective. Really terrific work.

The Shoulders of Giants

A number of years ago a photographer showed me some new work she was working on that involved nudes in the studio, with the model interacting with a piece of translucent, gauze-like fabric. And she had this model doing various poses, stretching the fabric across her body, etc.—very interesting work.

Now fast-forward to last week, where by sheer coincidence I had the chance to look at a large collection of work by an almost unknown photographer named Franz Berko, who photographed in the 1930s and did nudes with models interacting with large pieces of gauze material and draping them across their bodies, etc.

The work he did in the 1930s was almost an exact duplicate of the work that this photographer had done in the 1990s, and there is no way possible that this woman could have ever known about the work of Berko, because he's almost unpublished. He's a long-lost, forgotten photographer, which just goes to prove the point that there are no new ideas in the world. If you think Ansel Adams' work in Yosemite was new and creative and his sole ideas, then you ought to take a look at the work of Fiske, who did almost all the Ansel Adams photographs 50 years before Ansel did them.

Or if you think the work of Walker Evans and the FSA photographs of the old storefronts in the South are unique and new, then look carefully and compare his work to the work of Eugène Atget working in 19th-century Paris. When I hear the complaint in a workshop or critique session that "Oh, I've seen that work before; it's not new; it's not creative," as though somehow that discounts and dismisses the work, I just shake my head, because even old work is new to the photographer who's doing it for the first time.

And just because it's been done before doesn't mean it shouldn't be done again, because it might be done better, might be done with more insight. As Isaac Newton said, "If I've seen farther than others it's because I've stood on the shoulders of giants." Not bad advice for photographers, too.

How a Market for Collectible Artwork is Built

The other day an early issue of *LensWork*, actually *LensWork* #8,

sold on eBay for $33, which is about four times the cover price that we sold it for back in 1994.

There is a lesson here that I thought I would share with you, based on what I now perceive is the marketplace perception of the value of *LensWork*. I think I'm going to raise the price for every copy of *LensWork* to about $40, because clearly I should be getting some of that income. If collectors are willing to pay that, then why should it just be the seller who benefits? Shouldn't the producer also benefit?

Of course, $40 for a copy of *LensWork* means that only the pretty well-to-do are going to be able to afford it, but that's okay, because that means that we'll sell fewer of them so they'll be exceedingly rare commodities, which will increase their value, which will help me sell *LensWork* based on its potential to appreciate in the collectors' market.

So now when I sell *LensWork* it won't at all be based on the content of the magazine and its broad appeal, but rather on its ability to appreciate as an investment. And that's why you ought to be buying *LensWork*.

Of course, you probably see where I'm going with all of this. Why is it that so many people who make photographs look at the prices the collectors are willing to pay for a photograph and believe that they ought to charge that much for their artwork?

There's a lot more in this simple lesson than you might suspect. Think it through carefully.

There's a parallel here between making art, and the art market, and those of us who are photographers, and pricing issues, and etc., and it's simply this. Is it possible that the person who owned that early issue of *LensWork* and who sold it for $33 was only capable of doing that because since that time when it was originally published, we've continued to publish more and more issues of *LensWork*, and grow the market for it, and find new readers, and as a result of its popularity—that is to say, its broad base of people who

appreciate the publication—that this person who had an early issue of *LensWork* and wanted to sell it was able to find people who wanted to complete their collection of *LensWork* and were willing to pay a premium price for it?

Well, it's exactly the same thing for those of us who are making art. If we think that our artwork might someday be collectible and valuable, and people might be willing to pay large sums of money for it, is it possible that that will only happen if we continue to produce artwork and sell lots of artwork at affordable prices, and build a base of people who appreciate our creative output?

Because then, in time—fast-forward 10 years, 20 years, 30 years—there'll be enough people who appreciate our artwork that some collector down the line might take some of our early work, things that we sold for what might look like bargain-basement prices. But someday some collector might sell that at a very appreciated price simply because we did the work today to sell lots of work at affordable prices. The collector's market is one thing. But as producers, whether it's a magazine or a body of fine-art photography, our world and our pricing and our sales have almost nothing to do with what will eventually become the collectible market for our work, assuming that it survives the test of time.

The Original

Not long ago a friend of mine made a digital image, applied a little Photoshop work to it, and mailed it off to a few friends to say, "Gee, here's a photograph I did that I thought you might be interested in."

And he received back an e-mail from one of the recipients, who said, "Gee, this is a really terrific-looking image. I can't wait to see

the original," to which he responded that the e-mail was indeed the original.

I think this whole question about what is an original gets to be very interesting in this day and age when there are so many alternatives in how we apply the question of medium to the production of a photograph. It used to be, in my earlier days, that the original print was what I produced in silver. Everything else was somehow a replication. When I scanned an image and put it on a Web site, that was a duplicate or a reproduction. When it showed up in a magazine or in a book, that was a duplicate or a reproduction.

But now I'm not so sure the lines between original and reproduction are so clearly drawn. Who would have thought that the question about which is the original print and which is the reproduction would become such a dicey one? But in fact, it is. And I think this has a great deal of impact on marketing and offering our work for sale, because there is a differentiation between the value of an original and the value of a reproduction. But if you can't figure out which is which, how do you figure out which is the more valuable of the two?

Getting It Right, Getting It Done

There's always a bit of a dance involved in trying to create something, like artwork for example, and the dance is always between the two opposing forces of getting it right and getting it done.

Both of these can become obsessions, I've come to learn. I can be so obsessed about getting something right that I never finish it. I keep trying print variations. I can't tell you the number of times I've spent all Saturday doing a print until I thought I had it absolutely perfect in the darkroom, only to wake up Sunday morning and see the dried-down print and realize I could have done this,

I could have done that, go back in the darkroom, and spend all Sunday trying to get it right, only to wake up on Monday morning and repeat the process.

It's possible with something like photography that you can never get it right, because there's always something you could do. However, having said that, the other side of the coin is you can also be so focused on getting it done that you're willing to cut corners, and it ends up being not right at all. It is a very delicate dance, and knowing when to stop is just as important as knowing when to keep pushing. There is no ultimately right answer, I think, for this—at least that's my conclusion.

Now that I'm in my 50s, I realize this is part of what being an artist is. It's not just learning tools and techniques, but learning when it's better to stop and when it's best to push yourself yet still farther. I've learned to listen to that little voice that tells me which is right, even though sometimes I don't necessarily like what it tells me, when sometimes I'd rather be done but I need to push, and sometimes when I'd rather push but I really should stop.

The Camera as Impediment to Seeing

Thirty years ago I read a book called *The Thousand Mile Summer*, by Colin Fletcher, in which he describes hiking the entire length of the Colorado Canyon. In that book he describes how a few days into the hike he set up his little camera to take a picture of himself, recording some things that he was going to use to eventually publish the book, when a gust of wind came and blew the camera over, smashing it down onto the hard rock, destroying it, and he spent the next several weeks distraught because his only means of taking photographs was now destroyed.

But then it occurred to him that his camera was not his only

means of recording the event. He had that most valuable recording tool—the human brain, his ability to remember things. And he suddenly realized that the camera had actually been a deterrent to using his memory, because inherent in the use of the camera is the idea that we don't have to look at the scene now, because we can always go back and look at the picture for the details later.

Once he had realized that this was actually an impediment to seeing what was before him, he realized he had become liberated with the destruction of the camera, so that it forced him to look more carefully and see more deeply. And this, in my way of thinking, precisely defines the difference between those who use a camera as a recording device, and those who use a camera as an art-making tool.

Art makers are not people who use a camera to record life so that they can see it in detail later. The art maker is the person who specifically chooses to engage life most directly, most intimately, most intensely, and then they use the camera to reproduce or to record that feeling, not as a means to numb themselves to life so they can use the camera to pick up the details later.

When I find myself snapping away with the idea that I can always look later, it's my clue that I'm not engaging the truly artistic process but I'm somehow disengaged from the artistic process. When I'm at my best in making artwork is when I'm seeing most deeply, and at those times the camera is almost superfluous. And only then are the pictures I make the ones that I subsequently find out are the absolute best.

What's Happening to the Galleries?

It's always dangerous to talk about something that you don't know a lot about, and that's what I'm going to do here. I'm go-

ing to talk about the gallery business, because it seems to me that something is happening in the gallery business.

Maybe the gallery business is no different than it always has been; it's just that I'm noticing it now. But there are a lot of them closing. The Ansel Adams Gallery down in Pebble Beach closed. They actually moved locations to a less expensive real estate area. They stayed there for a while and then eventually closed the doors there permanently. Now it's available only as an online gallery, plus their locations in Yosemite.

In my old hometown of Portland there was a really terrific gallery called Josefsberg Gallery, owned by Steven Josefsberg. That gallery closed, and as I heard from friends of his and through his press release, it became more economically viable for him to lease the building to someone else rather than to continue to operate it as a gallery.

And that makes perfect sense. Real estate prices were going up, and there were a lot of things he could do with it. The gallery business is very, very difficult, and it seems to me that it shouldn't be. That is to say, there are more great historic photographs available now than there ever have been because history has been longer in photography than it ever has been, so we have more photographers making more images.

People love photography. One of the things I love to do is look at the pictures on the walls in TV shows or in commercials. It's amazing that they're almost all universally really classy-looking black-and-white photographs. People love photographs.

Why is the gallery business difficult? Why are all these galleries closing? What happened to the Witkin Gallery? What's happened to all of these great venues for selling photographs? I've had issues for a long time with the basic marketing approach, pricing, etc., and those of you who are longtime *LensWork* readers know my thoughts about this.

But I think there's something more fundamental going on.

There's a more fundamental shift in the business. There are more and more photographers like Michael A. Smith and Paula Chamlee who are choosing to market their photographs directly themselves. I don't know if it's the Web site; I don't know if it's photographers being fed up with the galleries; I don't know what it is, but I'd love to find out.

So-called Alternative Processes

If you've been in photography for a while you've probably come across the company called Photographers' Formulary, a terrific group of guys who make available all of the odd chemicals it takes to do all of the so-called alternative processes in photography.

I just received their workshop brochure for this year and I found it a real interesting thing in this regard: How did it come to pass that all of the processes that they promote and advocate are so-called alternative processes?

The word "alternative" implies that what they're doing is somehow odd; it's different; it's not normal. The normal processes would be, of course, normal, and the alternative processes are those that are not normal. So what's the normal process?

It occurs to me that the normal process is black-and-white gelatin silver, and all of the processes that they offer are platinum palladium, and gum bichromate, and etc.—all of the older processes that are not the current state of the art in gelatin silver.

What I find interesting in all of this is that a relative latecomer to photography, like gelatin silver, has become the normal process and everything else is alternative. In the midst of the revolution that we're in right now with all of the digital cameras and etc., are those someday going to become normal, and is gelatin silver destined to become yet another variation of alternative processes?

It seems to me that all of those so-called alternative processes, which predated the now so-called normal process, are just as valid a method of making photographic imagery as the normal processes now. And conversely, I tend to look forward into the future and think that the methods that we cannot now foresee that are going to be used to make images are just as valid as the methods we have today, or the methods that were from the past.

Image-making technologies are just image-making technologies, and where they occur in the history of the process does not influence the fact that they are all equally valid image-making processes, even though some of them may be relatively obscure by the current standards. The fact that a process is obscure doesn't make it alternative. It just makes it a little more rare—a fate I can't help but think awaits every single technology that photography uses if we just give it enough passage of time.

Thank You, David Gardner

For over 30 years, one of the most important names in all of contemporary photography was David Gardner. You may not have heard of him, because he wasn't a photographer—at least not in the sense that you and I would think of as the great photographers. But he probably did more to bring photography into your life and my life than any other individual.

He was the printer of fine-art photographic books. Gardner Lithograph was the place you went. If you were Ansel Adams, if you were one of the great photographers, and you wanted the absolute state-of-the-art reproductions for your images in book form, David Gardner was the guy that you'd turn to.

He was the man when it came to printing fine-art photography in the stunning reproductions that we were introduced to in the

last 30 years. He was the guy who single-handedly made 300 line screen tri-tones, such wonderful reproductions.

I mention David Gardner because I think he deserves our respect, and he deserves our gratitude, and it's very sad to me to see that his company, Gardner Lithograph, has ceased operations after all these years. Economic times and the changing technology caught up with them, and like a lot of businesses, your past glories don't pay today's bills.

But I'd like to tip my hat to David Gardner for all that he did for photography, because without him and his exacting printing standards, and his wonderful pursuit of the fine-art reproduction, so many of the books that have been influential in my life would have never come to pass. So if you happen to see this, thank you, Mr. Gardner, for all that you provided for all of us.

The Richness of a System

Here's an idea I'm not quite sure I can even get across, but I'm going to attempt to do it anyway: the richness of a system is determined by the number of variables there are in it.

Take cooking as an example. Think of the number of variables there are in cooking. You've got several different kinds of meat—beef, pork, chicken, fish, etc.—and several different ways to prepare them—roasting, frying, boiling, etc., casseroles, and all those things, and vegetables, and spices, and sauces. And by the time you look at all the permutations that are possible—literally a virtually unlimited number of potential recipes—you would say cooking is a very rich system that has no end to how far you can explore it.

Now let's look at black-and-white photography. Generally speaking, one of my concerns about black-and-white photography is that it's not a very rich system as it's currently been pigeon-holed

and defined. It's defined as a white mat board with a window bevel-cut, and this definition has almost no flexibility. It's a variable with only one possible answer.

If you think that's not true, just show up at your next work-shop with some blue mat boards and see what people say. When it comes to the color of the print, you can have a neutral tone or a warm tone, but if you show up at that workshop with a green-toned photograph or a blue-toned photograph, which it's possible to do, watch how people deride it.

So when you get right down to it, there are only a few variables in the presentation of a photograph: what size it is, what shape it is—square, rectangular, or maybe even panorama—and what the subject material is. There even appear to be some approved subjects and others that people just don't seem to spend much time photo-graphing.

I think this is why black-and-white fine-art photography tends, for the general public anyway, sometimes to be a little boring, a little repetitive, because it's not a very rich system. It doesn't have a lot of variables. And maybe we need to figure out how to introduce some more interesting and varied variables, so the possible permu-tations of what can be created in a creative photograph are allowed to blossom exponentially. This is what I mean by saying that the richness of a system is proportionate to the number of permuta-tions that it has available.

A Rose by Any Other Name

I love making points by drawing parallels, and here's a good example. What do we call a person who plays the guitar? And what do we call a person who plays the harmonica? And what do we call a person who plays the clarinet?

I suspect, in every one of these cases, we would tend to call them a musician, because the word guitarist and the word harmonicist and the word clarinetist are somewhat cumbersome. So, by the same token, what do we call someone who makes photographic images with a camera and a darkroom? And what do we call a person who makes photographic images with a digital camera and Photoshop and an inkjet printer? And what do we call a person who makes photographic images with alternative processes like daguerreotypes or platinum palladium prints?

In every one of these cases, I think we would tend to simply refer to them as a photographer, but there are those who disagree with this idea, because they think that somehow fundamentally the digital camera and the digital darkroom are so different from the traditional camera and the traditional darkroom—and other chemical processes, as far as that goes—that we ought to differentiate somehow between people who make images with digital cameras, and their output, from the rest.

There are those who are in the purely analog school of photography who think that images that are made with digital tools should not be referred to as photographs, and those people should not be referred to as photographers, that we ought to call them pixelographs or some such silly thing, and pixelographers or some equally silly thing. And I can't help but think that this is just a lot of turf protection and has very little to do with the process of making a creative and expressive vision with image-making tools.

A rose by any other name is still a photograph.

Instant Review in the Field

Looking back pragmatically, the most profound and educational experience I've had making photographs was the time I decided

to use Polaroid film in the field for a very specific project. I had decided that I would do a portfolio made from 3¼x4¼ Polaroid positive-negative film.

Obviously, this gave me the opportunity to look at positives, in the field, of the image I had composed, while the camera was still on the tripod. And I still had an opportunity to change the composition or the exposure as need be.

This instantaneous feedback was absolutely phenomenal. I learned more about photographing in those two or three weeks than I had in the couple of years before that. It was that unavoidable and inevitable delay between photographing in the field, and then subsequently back in the darkroom developing the film, and eventually making the contact prints and the enlargements, and seeing the result—that delay was so long that it made a disconnect between the process of photographing and composing and exposing, and the actual result.

It was difficult to connect the two together, but in the field with Polaroid, suddenly I found that there was instantaneous feedback that was incredibly valuable. I'd kind of forgotten about this until just recently, as I've now been shooting in the field for the first time with a digital camera.

I'm finding that same sense of learning curve and instantaneous feedback is the most underrated and most valuable aspect of photographing with a digital camera. It's like having an unlimited amount of Polaroid film in the field and having the ability to judge every single photograph, in two dimensions, on that little tiny screen, both for composition and for exposure. The only thing is, I wish it was an 8x10. I suppose the next most valuable photographic tool I'm going to need is a laptop.

The Size that Feels Right for a Photograph

It seems to me that every form of artwork has a size that's about right for it. A painting that's the size of an 8x10 photograph is a small painting, and a 3-foot by 4-foot painting is more typical of what we think a painting ought to be. That's about the right size, plus or minus. They can be huge. We see paintings that fill walls; we see paintings that are miniatures. But a normal painting has a normal size that's a wall-art size. A song in pop music is usually about three-and-a-half to four minutes long so it'll play on the radio for the right amount of time. That's the normal size.

So the question is, what is the normal size for a photograph? What feels right? Well, everybody has a different answer, and particularly right now big seems to be all the rage. Everybody wants to make 30x40 inch prints or 20x24 inch prints. But for me, a print has always been an 8x10 thing, maybe an 11x14, maybe 5x7, somewhere in that range, but it's small. It's handheld. It's something that I can look at intimately, that I can pull up closely and look at closely. That's the right size for a photograph.

And when I see these gigantic photographs that everybody seems to be wanting to do these days, I sort of feel like it's an anomaly. It's an odd thing. It's a trick thing. It's supposed to get bonus points because it's big, but really when you get down to it, it's always the quality of a photograph that counts. And to me, whether it's a 5x7 or an 8x10 or an 11x14, I can get all the quality I need in a photograph at that size. Photographs to me are small things, and I like them that way.

Lessons from a Bookseller

One of the most amazing retail operations in the United

States—possibly in the world—is Powell's City of Books. It's the most unbelievable bookstore in, of all places, Portland, Oregon. A lot of people think the Strand in New York City is the end-all and be-all of used bookstores, but I'm here to tell you, I've been to both of them and Powell's in Portland, Oregon puts them to shame.

Powell's was founded years and years ago by Walter Powell, who was a good-natured Ukrainian with a round face and white hair and wide-set eyes. He was a very interesting guy. I worked for him for a while when I was in college. He always had a big pocketful of wadded-up $5 and $1 bills handy so he could buy more books when people brought them in for him to take a look at. He was an amazing guy.

I asked him once how he got in the book-selling business. And he said, "You know, the funny part about it is I didn't really set out to be in the book-selling business. I was in the book-buying business," he said. "I just—I love buying books. And the problem," he said, "is that I got so many books that I didn't have room to store them anymore, so I had to start selling them in order to get rid of some of them."

And from that relatively humble beginning, from a guy who loved books, has grown this giant empire of a book-selling business that's now run by his son Michael. It's a wonder to behold.

The reason I tell this story is because I wonder if there is an application here for artists, for those of us who love making artwork, making photographs, and who make so many things that they start to clog up our closets and Light Impressions boxes. Maybe the idea for us is to follow the advice of a bookseller like Walter Powell and to sell our products at very affordable prices so that they go away, so that we've got room to make more. There's an idea here that's probably worth thinking about.

Humbuckers and Butyrate Bobbins

I occasionally buy electronics from an online resource called Musician's Friend. They're primarily a musical instrument company; they sell all kinds of guitars, etc. As a matter of fact, they have a retail connection, called Guitar Center, that some of you are probably familiar with. And because I occasionally buy from them I'm on their mailing list for their catalogue.

Here is a little excerpt from their most recent catalogue, announcing a limited edition 50th anniversary humbucker set. It says, "Seymour Duncan himself wanted to work with Musician's Friend to celebrate the 50th anniversary of an unsung hero of the guitar world. Seymour aimed to pay homage to Seth Lover, the original inventor of the humbucker. He chose traditional two-and-a-half-inch alnico V-bar magnets calibrated for optimal tone. He also used the original type metal spacer, wood shims, and butyrate bobbins. They are hooked up and wound the traditional Seth Lover way, and each set is made and engraved by hand in Seymour's custom shop in Santa Barbara. The lead wires are braided single conductor. The nickel covers are tastefully embossed with '50th Anniversary,' and each set is voiced like Lover's original 1955 prototypes and signed and numbered by Seymour himself. Limited to 300 sets."

That's what it says. Now, I have to confess, I'm not a musician. I have no idea what a humbucker is. I have no idea who Seymour Duncan or Seth Lover are, so their participation means nothing to me. But I did find myself wondering, as I stumbled across this in their catalogue, if some of the language in photography might sound similar. To people who aren't in the know, when we talk about platinum palladium prints, versus silver gelatin prints, versus giclée inkjet, pigment on paper, you name it, when we talk about archival processing of our prints, and how they were made with view cameras and hand processed, etc. etc., does it sound the same

outside of our world as this business about humbuckers sounds to all of us who are not musicians? Hmmm . . . I wonder.

What Sheep Tend to Photograph

There are trends in photography, and I was reminded of this recently at *photolucida* when it cropped up yet again. I first observed this years and years ago when Richard Misrach decided to photograph some burning cactuses in the desert in the middle of the night with a harsh flash, and suddenly it became all the rage and you saw lots of burning-cactuses-in-the-middle-of-the-night photographs.

More recently, Lois Greenfield discovered it was a really great trick to photograph dancers caught in mid-jump, flying through the air. They were wonderful photographs, but of course, being wonderful photographs, and imitation being the sincerest form of flattery, suddenly we had lots and lots of photographers doing groups of dancers caught suspended in midair and in the full pose of some dance maneuver.

Well, at *photolucida*, in the first 12 portfolios I reviewed, I had no fewer than four photographers show me work that was done with the Diana camera photographed from a low angle, pictures of what I would call middle-class American neighborhoods. And every single one of them used the following phrase to describe the work. They said, "I'm using space as a metaphor for exploring childhood memories."

Unfortunately, all four of these portfolios weren't, to my eye anyway, very interesting because they were dark, fuzzy, out-of-focus pictures of a neighborhood that looked like the kinds of things my parents probably threw out in 1954 because they were badly exposed, randomly composed images. But all four of these photog-

raphers thought they had done some really interesting, significant, and unique work.

But what was interesting to me was that there were four of them, and I couldn't help but wonder if somewhere in some magazine or some book this wasn't suggested as an assignment that might make a wonderful photographic project. It's easy to become sheep and follow today's trends because it looks like it might be the means to publicity and popularity. But as a publisher I can tell you what it more likely is than not is the means to dismiss your work as being imitative and unoriginal.

Honesty in Self-Critique

The task of being an artist requires ever so many skills—technical, psychological, etc. But I think one of most important skills that's often overlooked for those of us who are trying to be artists is the skill of being honest with ourselves, the skill of being able to look at the results of our work and decide if it accomplishes what we wanted to accomplish, or if it even says what we set out to say.

I've recently relearned this lesson because I was reviewing a body of work and the photographer kept telling me this work is about A, and when I looked at it, it was clearly not about A. It wasn't even about a letter of the alphabet; it was about orange.

That is to say, the subject that he said he was photographing was not at all the subject that showed up in the pictures. This wasn't metaphorical work; it wasn't full of symbol and allegory. It just wasn't about what he said it was, and I was fascinated by observing, psychologically anyway, how this photographer had created a world that was what he photographed but was not at all the world of what was in his photographs.

He was absolutely convinced, and there was no way I was going

to talk him out of it, that his photographs were going to be perceived and appreciated on an entirely different level than what the images portrayed.

And I couldn't help but go back and remember when I had gone through this phase in photography myself, thinking that I was putting all kinds of Zen-like, deep hidden meaning and symbolism in my photographs, only to find out on later reflection that what I was doing was kidding myself. It's a difficult thing to be totally honest, but it's absolutely necessary.

Black Densities

I hope you'll forgive me for a few minutes if I get a little bit overly technical, but we did the press check yesterday on *LensWork* #58, and there was an interesting moment in that press check I thought I'd share.

Of course, we print in duotone in *LensWork*, and that means we print two inks, one on top of another, and that allows us to get a particularly dark and deep black in *LensWork*. That's one of the things that makes it look so good. So here I was, measuring densities in the press check, and checking the densities that we were getting off the press as compared to original prints and, in this particular case, a book that another publisher had previously published of some work that we were including in *LensWork*.

For those of you who aren't familiar with density numbers, let me give you a little scale. Platinum palladium prints, generally speaking, top out at a maximum black of about 1.65. Gelatin silver prints will max out at a black of usually about 2.2 or 2.3, although a lot of gelatin silver prints you see will only be 2.0, but somewhere in that range gives you an idea. And that's one of the reasons gelatin silver is such a lovely material—its blacks are so black.

Well, yesterday on the press, printing duotone for *LensWork* #58, we're printing with a new paper and it really takes ink beautifully, and we were able to get with some consistency blacks of 2.26. This is gelatin silver kind of black. And I measured the black from the photographer's book whose work we included in *LensWork*, and their book, printed by a different publisher, in duotone, had a maximum black of 1.35. It just looked sort of battleship gray. And I tell you, it made all the difference in the world as to how these prints looked. Some of them just looked gray and flat, and the reproductions in *LensWork* looked—if I may say so without sounding too boastful—absolutely gorgeous.

I know such technical details, particularly when it comes to the mathematics of black, can be boring for a lot of photographers because the magic of a photograph is not in how black it is. But I tell you, it does contribute to the sense of three-dimensionality and depth that you see in a photograph, and we sure saw it yesterday on the press check.

It's one of the reasons why I think one of the most valuable tools a photographer can have is a reflection densitometer. It doesn't guarantee that you're making interesting images, but it does give you a way to measure tonalities and to know that what you're creating is as good as it can be from a technological point of view, in ways that are just not possible if you're not measuring. As the old management maxim says, "What gets measured gets managed."

Alternative Copyrights

Sometimes new technologies require that we ask and answer new questions that we didn't even know were questions until the new technology made them available to us. A good example of

that are the distribution possibilities that are now available to us because of the Internet.

It used to be that if you were a photographer and you wanted to distribute your images, you had a couple of choices. You could do original prints, which of course you copyright protected, or you could have your images show up in publications—magazines or books or whatever—and those were also copyright protected.

But in the age of the Internet we have more choices, because sometimes, just for fun, it's nice to be able to put an image out into the world and allow people to do something with it. Maybe you just want to share it. Maybe you want people to have access to it.

So, what lies in between fully copyright-protected images which don't allow any reproduction whatsoever without permission and possibly payment, and on the other hand, total free use under public domain, which means you have no control over it whatsoever? Well, this is one of those questions that we've never had to ask before because there didn't seem to be any need to ask the question.

But now, in the age of the Internet, it becomes an interesting question, and fortunately there is a group that is attempting to answer this question. It's called Creativecommons.org. I suggest you visit their website, because they suggest all kinds of alternatives to traditional copyright, including ways of notifying people that your artistic product is available for distribution, with certain restrictions.

For example, one use is that you may reproduce and distribute an image, but only with accreditation. Another variation is you may use it, but it must be unaltered; it must be in the original form, etc. They've created all kinds of different ways in which artists might want to share their work and inform the public of the rules under which they are allowing it to be shared, and they've drawn up a series of specific protection documents and language that allow you to choose various ways to share your work with oth-

ers without giving up all of your rights, and without imposing all of your rights. It's a very creative site.

Guilt and the Fallow Times

I've noticed over the years that a lot of things involved with the creative life happen in fits and starts. We get very creative for a while, and then all of a sudden we lay fallow. I haven't had but five or six blogs in the month of April, and this brought this thought back to mind because, quite honestly, I always feel a little guilty when this kind of thing happens to me.

I've felt this way in photography all my life. There have been periods when I become very productive and very intense for weeks, months, even years at a time. And then there will be other times when I just don't seem to accomplish much at all.

Sometimes that's been because I haven't had a darkroom; more often it's been because life gets really busy and I just don't have time to do photography because of the other demands that are being placed on me. It doesn't make any difference, however, as to why I'm not getting the work done relative to my feeling of guilt about simply not getting it done.

I expressed this to a friend of mine years ago who makes a living selling fine art photographs; he's one of the few people I know who does. And he said that he noticed exactly the same thing when it came to sales of his work. Sometimes he was selling things like crazy; sometimes he wasn't. He had observed this same pattern for years until it finally dawned on him that the pattern was important, because he learned that when he wasn't selling work it was OK; he just kept doing what he was doing and eventually the sales started to pick up.

And he realized that when he got anxious because he wasn't

producing anything, all he was really doing was just making his life miserable, because he had to have faith that things happen the way they are supposed to happen, and that discipline and guilt are not necessarily opposites, that in fact it's OK to just trust the natural process unfolding as it needs to sometimes. And sometimes that means you'll be productive and sometimes you won't, but in the long run it's best to trust yourself rather than to spend a lot of time and energy being anxious or guilty.

What's Left When You Can Print with Ease, at Will

I've always assumed that photography was supposed to be a difficult thing to do; at least it always has been in my life. Just the process alone of exposing and developing and printing a nice photograph has been a very significant challenge. This challenge has occupied untold hours of my life in the darkroom, in the field, fussing around with chemistry and materials. And I think of all the workshops that I've attended, and all the experiments and tests that I've done in order to make a decent print.

But you know, that's not what photography is really about, and as I get older and as the technology changes, I keep learning this lesson over and over again. And a good example of that came to mind this week. I received the new Adobe Photoshop CS2. This software just keeps getting better and better, and it keeps getting easier and easier to make really stunning photographs from the technological point of view.

What I can produce now, today, with ease, I could not have produced at all 20 or 30 years ago when I started photography. Now, some of that was because I wasn't skilled enough, but a great deal of it was because the technology wasn't skilled enough. So

here I am, having survived 35 years of tests and chemistry, and I'm lucky enough to have seen the technology evolve to the point where, with a certain application of skill, I can produce a pretty good print at will. Some people can do that in the darkroom at will. Some people can do it digitally at will.

The point is, when you can produce the work technologically at will, what's left? What's left is the whole reason to be an artist. And that is when things get really difficult, because now the challenge is no longer merely making tones but making interesting artwork. And that is not something of molecules but something of the soul, and it's the point where so many people give up art and take up golf.

Postcards as Publicity

Most of us want to get our work seen. We want to be out there; we want to be visible. And one of the most common ways that people strive for visibility with their artwork is to send out postcards and announcements of their shows, and books, and exhibitions, etc. We probably get 10 postcards every day announcing someone's work.

For those of you who are highly motivated to do postcards of your work and send them out, I thought it might be interesting to hear what the publishers of the world might think when your postcard arrives, because I have some perspective on this.

First, you need to understand that you are one of about 10 postcards arriving every day, and the implication of that is if you send out a postcard, it's not going to be very unusual, it's not going to make your body of work stand out, it's not going to make you more visible. It's going to make you, instead, one of a crowd.

It used to be that if you sent out a postcard maybe you did be-

come visible. There was something really positive in it. But now there are so many people doing so many postcards that I don't really think it buys you all that much. My interface with the average postcard is probably measured in fractions of a second. I look at them; I toss them out.

Now, some people might say, well, at least I look at them. But the question is, looking at them is one thing, but taking action, being inspired to phone up a photographer, or go to an exhibition, or buy a book, or in some way have that postcard influence my thinking as a publisher is just nonexistent. It just doesn't happen.

The first and most important reality about all publicity is if you want to be seen you have to rise above the crowd, and to send out a mere postcard these days does not make you rise above the crowd; it makes you blend into the crowd. If you want to do real publicity, if you really want to get your work seen, you've got to do something more, something more impressive, something that's higher quality, something that's better from the viewer's point of view than some post-office-handled, beat-up postcard that shows up and becomes another one of just a stack of postcards.

Known for Ten, Famous for One

A friend of mine once shared a very interesting theory of hers. I don't know, quite honestly, if this was her original thought or if she was just paraphrasing something she'd heard elsewhere, but although I can't cite the definitive source for this idea I still think it's a fascinating one to think about.

She said that any photographer who's worth their salt has probably made 10,000 negatives. They've probably printed 1,000 or so prints. They've probably exhibited 100 or more prints. They might

be known for about 10 prints, and they might be famous for one or two or three only.

I have to tell you, when I first heard this I really resisted this idea, because I found it so incredibly discouraging as a photographer. I didn't find it untruthful; I found it discouraging. I don't know how many photographs Cartier-Bresson or André Kertész or Edward Weston made in their lives, but I can pretty much guarantee you it's a lot more photographs than the ones we know them for.

But it's this idea that there is virtue in volume that I resisted, because I tend to want to think that virtue is in genius. Unfortunately, I've had to conclude in my life that although there is virtue in genius, there is also virtue in mere productivity, and that those of us who make the most photographs and work the hardest are very likely to be the ones who are most known.

There is, of course, no guarantee—you can work your whole life and die in obscurity. But there is one indisputable law that cannot be denied, and that is if you don't do the work, you won't make great photographs. Like so much in life, I guess art also is 99% perspiration and 1% inspiration.

150,000 Slides

I had a chance to visit the studio of a commercial photographer friend of mine; he's actually a stock photographer. He was showing me his facility and his office, and he had this huge bank of filing cabinets that piqued my curiosity. I said, "What's in these?"

He said, "Well, that represents about 150,000 slides that are the best work of my life and are the ones that we actually offer through stock agencies, and it's how I make a living."

I got to thinking about that. A hundred and fifty thousand

slides, representing the good images—not all the brackets, not all the bad ones. That was the result of his life of work. Well, that was impressive and I was sort of humbled by it, because I certainly don't think I have 150,000 good negatives, so the sheer volume of his work was quite impressive.

But it also dawned on me what an odd thing photography is that a person can make 150,000 finished pieces of work in the hopes that some of them will be appreciated and paid for by clients so that you can make a living doing it, and that the few images that do sell out of the 150,000 slides have to pay for all the other slides that don't ever sell, and for all the other slides that don't make it into the filing cabinet.

This individual expended a tremendous amount of energy simply to organize all of that, to put all those slides into sleeves and file them, and keep them organized in such way that he could put his hands on them. Then we got to the part of the conversation where the rubber met the road, and he looked at me with a certain forlornness in his eye and said, "You know what? Now all of my clients want scans. What am I supposed to do?"

It made me realize that all of our organizational efforts are at some point down the road likely to become obsolete labor, and maybe the best strategy all of us photographers can employ is to spend the least amount of time organizing, because in some regards it's all going to be tossed out when the technology changes.

Photography – The Nondextrous Art

Here's an odd but interesting observation about photography and about being a photographer: every single art form that I can think of requires incredible manual dexterity—eye-hand coordination that is far above the average human being's ability to control

the muscles in their hands. Think of musicians, think of painters, think of calligraphers, think of even sculptors—they have to have this incredible eye-hand and manual dexterity that is of the subtlest form.

And then there's photography. We are the ultimate mechanical art form, in which the mechanics of the machines we use has completely taken the place of any sense of manual dexterity. About the most critical manual-dexterous thing I have to do as a photographer is to screw a filter in front of a lens. If I can do that, I can make photographs. Even dodging and burning in the darkroom doesn't take much manual dexterity; it's kind of a crude thing.

It's practically a cliché when you ask a photographer how they got started in photography that they'll say something along the lines of, "I wanted to make art, but I couldn't draw, I couldn't paint, I have no ability to do the traditional arts, and because I can't draw or paint I decided to pick up a camera and try photography as my form of expression."

I think this may actually explain why one of the most fascinating digital darkroom tools is being used by almost no one who is a photographer, and that's the absolutely wonderful software program called Corel Painter, in which a person can use a stylus on a pressure-sensitive pad to do painting and additional things to a photograph that can't be done with the camera but can be done manually, dexterously, like drawing or hand-coloring. But I don't see anybody doing that, and I suspect it is because none of us are very good with our hands.

Writers and Calligraphers, Photographers and The Darkroom

I love looking for parallels between photography and its vari-

ous aspects and other art forms, because I often find that there's something interesting to learn there. And one of the parallels that's fascinated me is the parallel between being a writer and being a calligrapher. They're two completely different art forms.

One has to do with creating a story and getting it published. The other has to do with crafting letters and a design, and producing something by hand. True, writers can be calligraphers and calligraphers can be writers, but it is not important that a writer be a calligrapher, and it's not important that a calligrapher be a writer. They are seen as two completely different things.

Similarly, in photography I think there's a real difference between a person who is a photographer and a person who is a printer. We don't normally think about it that way. We think that a photographer is someone who makes pictures and also does darkroom work, at least those of us who are involved in fine art black-and-white photography. That's the normal situation—the photographer does the darkroom work.

But I suspect that's not a necessary implication for the photographer to also be the darkroom mechanic, any more than it is for a writer to be a calligrapher, because I think it makes more sense when we think in terms of a photographer being a person who is an image maker, and the darkroom person is someone who makes the artifact.

In fact, a lot of photographers work that way, people like Howard Schatz, people like Duane Michals, who are terrific artists but don't do their own lab work, as it were. If we choose to do lab work or our own digital darkroom or whatever, well, great. There's no reason not to. But it's not necessary, any more than it is necessary for the writer to be the typesetter or the calligrapher of his ideas.

The Infection of Convention

We live in a world of conventions, and I think nothing illustrates this for me more tangibly than the world of fonts and typesetting, which of course as a publisher I'm involved in to a great degree.

I can illustrate this by pointing out that there are certain typefaces that communicate so strongly that you just cannot use them out of school; you cannot use them against the stereotype. For example, a typeface like Ponderosa just has to be used in the context of a Western something or other or it just doesn't make sense. Or a typeface named Jan Brady has that certain look of a 1960s sitcom television show, and to use it in any other way miscommunicates something that just is discordant.

By the same token I think there are certain conventions, certain clichés, if you will, in photography that have the same sort of reality. It's very, very difficult to take photographs of nude women, for example, who are not absolutely beautiful nude women. It's a very discordant thing, against cliché and stereotypes, to make photographs of nude women who are not young and not beautiful and not absolutely paragons of female physique. But it doesn't have to be that way, other than the fact that it's a convention.

Similarly, when we go to the desert Southwest, most people tend to make the same kinds of photographs of the sand dunes, or the rocks, or the trees. These conventions are so strong, and they're so difficult to work against, because the hidden communication in terms of the choice of subject material is just like the hidden communication in the choice of typeface. Our conventions are so ingrained in us that we can hardly see around them.

The converse of this, of course, is that outside our culture, where people don't know these conventions, we have to be very, very careful because we may think we're communicating something with a convention which to the uninitiated is absolutely a blank, that

they get no communication whatsoever. It's really interesting to be aware of these things as we're making art, and how symbols and conventions infect our art, either positively or negatively.

The Movie Tomorrow, *Comment #1 – Good Content Can Survive a Variety of Media*

I watched a movie last weekend I wanted to discuss because it was so interesting, and I think there are some lessons for photography. The movie is a very, very obscure one, called *Tomorrow*, and it stars Robert Duval.

I'd never heard of the film, and I found it when I did an Internet Movie Database search for Robert Duval movies, having a bit of a Robert Duval film festival here in our house. I found this film, and it was absolutely fascinating for several reasons, first of which is it was originally a novel written by William Faulkner, which was then picked up by the great writer Horton Foote and turned into a script for the theater, which Robert Duval acted in, in a very small theater, which from there got converted into a screenplay by Horton Foote.

The movie was produced in the early 1970s, and it was a DVD of that movie that we watched. Now, there are several things that are fascinating to me about that. Think of the iterations that this story went through. Its first form was a novel, then a theatrical performance, then a film performance, the same content morphing through various media to find its way eventually to me, and obviously to people who will be able to see this in the future.

Isn't it interesting how content can morph from medium to medium? This tends to show me that good content is independent of good medium, and in fact, good content can survive regardless of

the translation from one medium to the next—not always, but in many cases I think this is so.

The Movie Tomorrow, *Comment #2 – Following the Career of an Artist*

Continuing my discussion of the movie *Tomorrow*, starring Robert Duval, there's another aspect of this movie that I found fascinating. Robert Duval is a really terrific actor. There's hardly anything that he's been in that I don't really enjoy, and he stars in one of my favorite movies of all time, *Lonesome Dove*. He did a great job in that, so that's why I was searching for Robert Duval movies and came across this little film.

Now, interestingly enough, this little film evidently had almost zero theatrical exposure back in 1972, and could have just as easily been lost to history and certainly lost to my personal history—that is to say, I would've never seen it—had it not come out on DVD and I had been able to find it. But I found it by zeroing in on one particularly talented individual whose work I enjoy.

The reason I bring this up is because I think exactly the same thing takes place in any art form. When I find a photographer whose work I particularly enjoy, it's been very useful to go back and look at everything that photographer has done, everything I can find—every book, every little publication, gallery exhibition, etc., because following a person's career and seeing how it evolves over time has been very useful to me as an artist, to think about what it means to be an evolving artist.

Now, in the case of Robert Duval, this film was certainly not very important to him financially; it may not have been important to his career. But the way he speaks about it on the extra content of the DVD, it was very important to him emotionally, and as an art-

ist growing and learning his craft, and he thought this was a very pivotal point in his career, working on this film.

And I suspect exactly the same thing could be discovered if we talked to lots of photographers about images that they made, or exhibitions that they had, or books that they published that maybe weren't particularly popular, but were very influential in their personal development. So I might suggest that a good Amazon.com search, or a good Google search on the net for a particular photographer you enjoy might discover some real nuggets that are well worth searching for.

The Movie Tomorrow, *Comment #3 – Helping Photographers in the Future*

I've been discussing a fascinating movie called *Tomorrow*, starring Robert Duval, and here's another interesting idea that came as a result of watching this movie. In the comments on the DVD, Horton Foote, the screenwriter and a well-known and famous writer in his own right, talks about how difficult it was during the filming of the movie for them to get a courthouse in the South to allow them to film the courthouse scenes, because it seems in the early '70s, when this was being filmed, a lot of the films about the South were very uncomplimentary to the South.

As he put it, every film that had a courthouse scene from the South involved a murder, a rape, some racist action, or something, and a lot of the courthouses in the South were understandably bothered by the fact that they were getting a lot of bad press in all these Hollywood films.

So when they went to film this film, which was not going to be uncomplimentary about the South, they had a very difficult time finding any community that was willing to let them use their

courthouse in fear of promulgating additional negative publicity about the South.

They eventually found one through a personal connection of Horton Foote's, and it came off just fine in the movie, but what this illustrated for me is the importance that each one of us photographers has in terms of leaving behind a positive reputation for those photographers that might come after us.

That is to say, as a photographer I can have a negative influence on those who might come after me in photography if I leave in my trail a wake of damaged relations, angry people, a sour taste in people's mouth about working with photographers. As a photographer I have a responsibility to all my fellow photographers to make sure that I don't do things that make their photography more difficult in the future as a result of my not having been a good photographic citizen working out in the world, or the landscape, for the urbanscape, or whatever today.

The Movie Tomorrow, *Comment #4 – Reusing the Best Nuggets*

I have one more comment about the movie *Tomorrow*, starring Robert Duval, that's very interesting. The first words that came out of his mouth in the movie sounded something like, "Yeah, that's right," and I thought, "I've heard that voice before."

The more I listened to it during the first few minutes of the movie, the more I realized it was the exact voice of Billy Bob Thornton in the movie *Sling Blade*. The only difference is, at the end of it, Billy Bob Thornton added that wonderful phrase that we all know if we saw the movie, "Uh-huh."

Well, Robert Duval invented that voice long before the movie *Sling Blade*. He invented that voice in 1971 as he was filming this

obscure film that hardly anybody ever saw. And in the extra comments on the DVD, Duval talks about having heard that voice from a farmer in Kansas. Duval describes it as though he heard a cow talking, and he thought, "I'm going to use that voice somewhere in a film," and he did in this film.

Now, fast-forward a couple of decades to the Billy Bob Thornton film. Well, interestingly enough, Billy Bob Thornton cast Robert Duval as the father in the film *Sling Blade*. I can't help but wonder if Duval didn't suggest that voice to Billy Bob Thornton, or maybe Billy Bob Thornton had seen this obscure Robert Duval film.

The reason I bring all this up is because to me it was a wonderful lesson of how reusing materials that we've discovered early on in our career, picking up themes, nuggets, little aspects of a piece of artwork that we can reemploy, is such a fascinating thing to do. It's not copying; it's reinventing and reusing the experience of our earlier creative life. It's a great idea. It makes me want to go back and look through all of my early work to see if there's any little snippet or nugget of a creative idea I can employ today in a re-used, reworked fashion that might make it even more meaningful in today's work than it was back then.

If You Build It

The other day I was reading a book of short stories that had been edited and compiled by W. Somerset Maugham, and in his introduction he made the very interesting statement that anybody who is a short-story writer needs to understand that the means of distribution for short stories is the magazine world, because that's where short stories show up.

Very few short-story writers get a book published of their short stories. You pretty much have to be famous, well known, well read,

in order to achieve that high status. So, in the real world, because magazines consume and publish short stories, that is the means of distribution for short-story writers. So, if it weren't for magazines, he proposed, there wouldn't be a reason to be a short-story writer, because you wouldn't have any way get them out there the world so that they could be seen and read.

Well, it dawned on me that exactly the same thing could be said about one of the newest and I think most exciting means of publishing and distributing photographs, and that's the Acrobat PDF file. There is no way right now to easily distribute Acrobat PDF files. You can't really do it via the Web, because the files tend to be too large, unless you down-res them and downsize them so much that the images become pixelated and a little bit soft.

So, we're very excited here at *LensWork*, in this *LensWork* extended CD that we're doing, to provide a bonus gallery where photographers can send us their PDFs and we can publish them and distribute them to a much wider audience than you could ever do by yourself. It's sort of our hope that the *LensWork* extended CD becomes a vehicle to create a whole new publishing medium for fine-art photographers and their individual projects.

So, please consider this an invitation. Take a look at our submission guidelines. See what we're looking for in the form of a PDF submission, and if you've got a project and you're looking for an audience, think about the *LensWork* extended CD. It's a great way to get your images out there, to get them seen, and for those of us who love looking at photographs it's a great way to see work that we probably couldn't ordinarily see, at least not without the severe compromises of Web site distribution, or without requiring the photographer to fund an expensive book project.

The Death of Reciprocity Failure

For reasons I am absolutely unaware of, and I'm sure exist on a subconscious level and would be of great interest to Dr. Freud, I've been drawn my entire life to photograph in very dark places; not that I make dark photographs, but that low-light-level areas have always been places where I seem to find great photographs.

So, by implication, I've spent my entire life dealing with the problems of reciprocity failure. I cannot tell you how many 45-minute exposures I've had in my days, when my light meter said exposed for eight minutes but I knew I had to expose for 45 minutes and then use compensating development to avoid increasing contrast too dramatically.

I was recently photographing in a place that required every single exposure to be about two minutes. In the world of film, that would have meant seven minutes and 30 seconds on every single one of those exposures, and I cannot tell you what a joy it was with my digital camera to make a two-minute exposure in exactly 120 seconds.

This is one of those small things that doesn't sound like it would make a big difference, but when you're out in the field and you've got four hours to photograph, the complications of reciprocity failure could actually limit the number of compositions I could photograph, simply because I had to take so long to create the proper exposure in film. Now I don't have to worry about that because the digital camera that I used for this particular project has no reciprocity failure whatsoever, and my exposures were able to come out perfectly without requiring any of that lengthy compensation. I'd never heard anybody talk about the fact that digital cameras don't exhibit reciprocity failure, but when I discovered it I found out that sometimes it's these little things in life that can make such a substantial difference.

The Likelihood of Experimentation

In 1988 I spent the day photographing down on the Oregon coast and I came across a dead fish that had washed up onto the beach. It was starting to deteriorate and be eaten by the seagulls, etc., and it captivated me and I decided to photograph it.

Now, certainly I'm not the first one to photograph dead animals on the beach, and I'm probably not going to be the last one to do it, but nonetheless that's not a reason to not photograph it. So, because it captured my eye and I was interested, I went ahead and made the exposure.

The negative has sat in my negative files ever since, and I haven't done anything with it to enlarge it or to even give it any second consideration, because I knew specifically it was a bit cliché, and after all, it was a picture of a dead fish, so it's not going to be a likely one that I'm going to sell, or that anybody's going to be interested in.

But nonetheless, because it had intrigued me, I'd photographed it and there it was. Complicating matters, I knew it was going to be a very difficult print to make, because it was going to have to be printed absolutely perfectly. So, from the creative point of view, where creativity meets production, I have to admit, in the pragmatic world I weigh the cost of time and energy and production versus how important this image is going to be to me, to my career, etc. When the production logistics are very, very difficult and the resulting image has very little reward, it's hard to get highly motivated to want to spend a lot of time working with that image.

And so, quite honestly, I had never done anything with the fish picture. But then along comes the world of digital printing and Photoshop, and suddenly I found myself intrigued by the image, because I could spend a little tiny bit of time just to see what's there. I was willing to experiment because experimentation was so easy, and interestingly enough, when I started to experiment with

it what I discovered is there is a lot more of interest in this negative than what I'd originally thought.

The freedom that I found in playing around with this image in the digital darkroom was a real advantage, because essentially it allows me to do a lot more experimentation a lot more easily, and therefore I'm a lot more willing to try risky things, to gamble on negatives that I don't really have a lot of confidence in. Even if my final print is going to be out of the wet darkroom, this ability to experiment digitally will help me learn the negative. So in a funny way, when technology makes our creative path easier, it seems it also tends to free us up to try things that are a bit more risky, a bit more dicey, a bit more experimental.

Photography and the Human Condition

One of the big photography magazines is sponsoring a contest right now, and you can enter the contest, and send in your pictures, and hopefully win some kind of a prize or something. And there's all kinds of comments that I could make about this contest, but I'd like to approach it from a slightly unexpected angle and that's this:

There are 12 categories in this particular contest. They have category number one: nudes, body, dance; category number two: nature, landscape, and seascape; category three: abstract pattern and texture, etc., photojournalism, streets and portraits, advertising.

Is there anything that strikes you odd about those categories like it does me? Maybe it's just me. I don't know; maybe I'm being too picky about this. But I've never thought that photography was about the subjects that are photographed, but rather I tend to think that photographs are about the emotional content of the image and

what it communicates about the photographer's ideas, or emotions, or statements, or reactions to the world.

There's a lot of reasons to make fine-art photographs, but they all have in their essence something in common about communicating the human spirit, the human reaction to life, and what our reaction as artists is to what goes on around us. So when I saw this contest category list, the first thing I thought of is, "Would it make more sense for the categories to be something like, 'Show us emotion,' 'Show us sadness,' 'Show us joy,' 'Show us victory,' 'Show us concern,' 'Show us caring,' 'Show us compassion,' 'Show us gratitude'?"

Those might be more interesting categories in which to judge one photograph against another, rather than putting all the landscapes together. To me, what groups of photographs have in common is not their subject matter, but rather what they communicate about the human condition.